IMAGES
of America

LEXINGTON

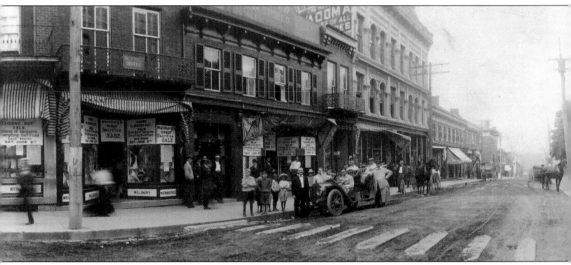

ON THE COVER: This 1909 photograph is a view of Weinberg's store located on Main Street across from the Lexington Hotel. Isaac Weinberg, shown standing in front of his store, initially opened a small business that expanded to become the town's first department store. The store stocked ready-to-wear clothing, millinery, toys, musical instruments, and sheet music. Weinberg's interest in movies led him to bring Hollywood films to Lexington for viewing at the State and Lyric theaters. (Courtesy of Rockbridge Historical Society Collection; Special Collections, Leyburn Library, Washington and Lee University.)

IMAGES
of America

LEXINGTON

Sharon Ritenour Stevens and
Alice Trump Williams on behalf of
the Rockbridge Historical Society

ARCADIA
PUBLISHING

Published by Arcadia Publishing
Charleston, South Carolina

Printed in the United States of America

Library of Congress Control Number: 2008941786

For all general information contact Arcadia Publishing at:
Telephone 843-853-2070
Fax 843-853-0044
E-mail sales@arcadiapublishing.com
For customer service and orders:
Toll-Free 1-888-313-2665

Visit us on the Internet at www.arcadiapublishing.com

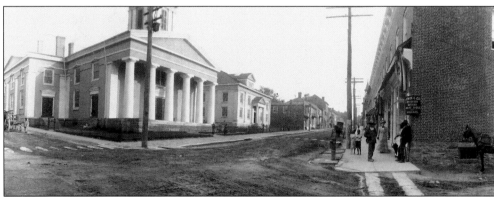

On the day the cover illustration was made, the photographer turned his camera from north to
south. His second picture was of the Lexington Presbyterian Church and the adjacent Sunday
school building. (Courtesy of Rockbridge Historical Society Collection; Special Collections,
Leyburn Library, Washington and Lee University.)

CONTENTS

ACKNOWLEDGMENTS

The Rockbridge Historical Society's archival collections are housed at Special Collections in Leyburn Library at Washington and Lee University. Many of the photographs in this book are from the Rockbridge Historical Society (RHS) and other collections housed at Special Collections in Leyburn Library. The authors are most grateful to Lisa McCown, Vaughan Stanley, Edna Milliner, and Elizabeth Teaff for their assistance at W&L's Leyburn Library, to Diane Jacob and Mary Laura Kludy at the VMI Archives, and to Cathy Wells in the audio-visual department of VMI's Preston Library for their assistance. Peggy Dillard at the archives in the George C. Marshall Library provided valuable assistance. We thank Michael Lynn and Heidi Wing at the Stonewall Jackson House, Keith Gibson and Barbara Blakey at the VMI Museum, and George Warren at the RHS's Campbell House for the images and pertinent information they furnished. Assistants Anna Bangley, Gordon Williams, and Martha Spencer provided valuable research and editorial assistance. We thank Barbara Blakey, David Coffey, Keith Gibson, and Pamela Simpson for reading the draft manuscript.

The authors thank members of the community who shared their collections and allowed us to scan their photographs: T. G. Woody, David Coffey, Dan Coffey, Al Gordon, Jeremy Leadbetter, Alvin Carter, Skip Hess, Mary Frances N. Cummings, John Raynal, Matthew Paxton, Charlene Jarrett, Katie Letcher Lyle, Charles Phillips, Charles Pearson, Lila Rogers, Kathryn Wise, Hope Hennessey, Stewart Macinnis, the Lexington Fire Department, the Woods Creek Montessori School, the Lexington *News-Gazette*, and the *Roanoke Times*. The Rockbridge Historical Society with Peggy Hays as president supported our mission, Ted DeLaney provided valuable information, and many people in the community offered helpful suggestions and advice, for which we are grateful.

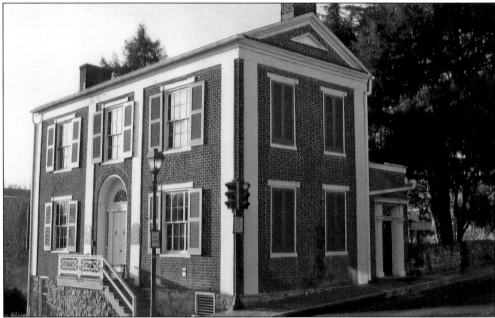

The Rockbridge Historical Society is located at 101 East Washington Street in the Campbell House. The house was built by Alexander T. Sloan in 1844. In 1866, the four Waddell sisters bequeathed the property to Hale Houston. He then purchased the neighboring house, now called the Sloan House, at 107 East Washington Street. The houses were given to the Rockbridge Historical Society by Leslie Lyle Campbell. Along with the Castle on Randolph Street, they are rented by the society for income. The RHS was established in 1939 to preserve local history. (Courtesy of A. T. Williams.)

INTRODUCTION

Lexington, the seat for Rockbridge County, is located in the beautiful Valley of Virginia, within minutes of the Blue Ridge Mountains. A quiet college town, its current population of 6,776 shares its 2.5 square miles with approximately 1,400 cadets at Virginia Military Institute and 2,000 undergraduate and law students at Washington and Lee University. Main Street is part of the Valley Pike (Route 11).

History and scenic atmosphere are major commodities and attractions for Lexington, Virginia. The downtown is an historic area that looks much like it did in the 19th century: historic buildings have been preserved and restored and the utility lines are underground. Washington and Lee University and Virginia Military Institute's campuses, the central business district, and older residences are listed in the National Register of Historic Places.

Lexington's main sources of employment are related to Washington and Lee University, Virginia Military Institute, and tourism. In addition to mountain scenery, Lexington attracts those interested in the Civil War, Stonewall Jackson, Robert E. Lee, and George C. Marshall. Lexington is the final resting place for Stonewall Jackson and Robert E. Lee, along with their horses. Lee's Traveller is buried outside Lee Chapel, and Jackson's Little Sorrel is mounted and on display in the VMI Museum. Within a few blocks, one easily visits the Stonewall Jackson House Museum, Lee Chapel Museum on the campus of W&L, the VMI Museum, and the George C. Marshall Library and Museum.

Main Street is Route 11—the Valley Pike/Great Road. The city, W&L, and VMI are interconnected; the two college campuses adjoin, and the George C. Marshall Library is a bridge between the two. Thomas J. "Stonewall" Jackson taught at VMI from 1851 until 1861, when he departed Lexington to fight in the American Civil War. Jackson's house has been restored and is a thriving house museum in downtown Lexington, only a few blocks from Jackson's grave in the cemetery bearing his name. In October 1865, Robert E. Lee became president of Washington College in Lexington, where he served for five years until his death in October 1870. General Lee is buried in the family crypt beneath Lee Chapel. Upon Lee's death, his son George Washington Custis Lee—who taught at VMI after the Civil War—was named president of Washington College, which became Washington and Lee University the following year.

George C. Marshall graduated from VMI in 1901. His first bride, Lily Coles, was a young lady who lived near the VMI gates (her house is now part of the VMI campus), and he remained close to his alma mater and to Lexington. The George C. Marshall Library and Museum was dedicated in May 1964.

The first chapter, "Downtown Lexington," focuses on the buildings and businesses in the center of town. The second chapter is titled "Community" and includes the fire department, the schools, the arts, and the people. The arts are the heart of this small town, and the faculty and spouses at both colleges are leaders in promoting the arts here. Chapters three and four naturally became "Washington and Lee University" and "Virginia Military Institute." Since Jackson was defined by his military relationship, he is part of the VMI story. Lee fit into the chapter on W&L. George C. Marshall is among VMI's most illustrative graduates, and the George C. Marshall Foundation is adjacent to the campus of VMI.

The images are essentially in chronological order. Because of limited space, hundreds of photographs that begged to be included were reluctantly left out. Every effort was made to include something related to each group. Lexington is a town of people dedicated to many diverse interests, and this represents only a few of them. Thomas J. Jackson described Lexington in September 1862 to his sister: "Of all places . . . this little village is the most beautiful."

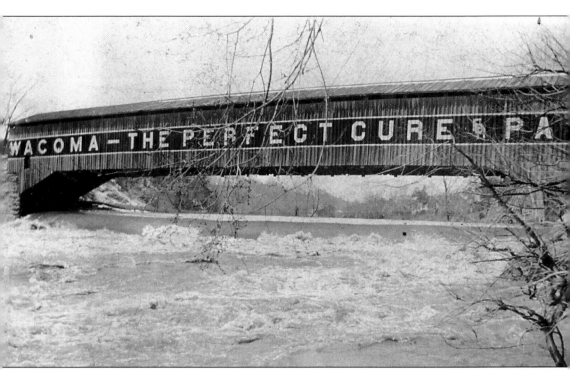

For many years, the road into Lexington from Staunton crossed the North River using a covered bridge. Note the advertising painted on the side of the bridge: "Wacoma—The Perfect Cure." Like the buildings at Jordan's Point, the successive wooden bridges were repeatedly washed away by high water. (Courtesy of Rockbridge Historical Society Collection; Special Collections, Leyburn Library, Washington and Lee University.)

One

DOWNTOWN LEXINGTON

This little village is the most beautiful.

—Thomas J. Jackson

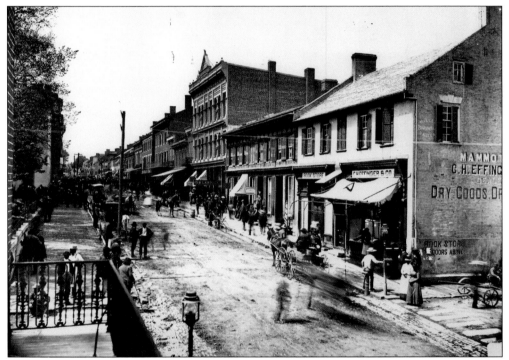

On January 12, 1778, a Virginia law specified the dimensions of Lexington. James McDowell surveyed the original area for the town, measuring 1,300 feet long and 900 feet wide, and it had six streets: Jefferson, Main, and Randolph Streets going north and south with crossing streets Nelson, Washington, and Henry Streets. There were 36 half-acre lots with two lots designated for the courthouse and jail. This 1890s photograph shows a robust Main Street, and the Book Store located across from the courthouse was a popular spot. Established as early as 1852, the Book Store was operated by Dr. J. W. Paine followed by John B. Lyle, who ran an "automatic book store," where customers were only asked to make a proper entry on a slate for what they had taken. Lyle was a close friend and spiritual advisor to Thomas J. Jackson. Walter Bowie ran the store until W. C. Stuart, a prominent businessman, bought it. At Stuart's death, employee Henry Boley continued to run the store for the family until he and H. Crim Peck took ownership. The store later moved several doors south on Main Street. (Courtesy of Michael Miley Photograph Collection; Virginia Historical Society, Richmond, Virginia; Special Collections, Leyburn Library, Washington and Lee University.)

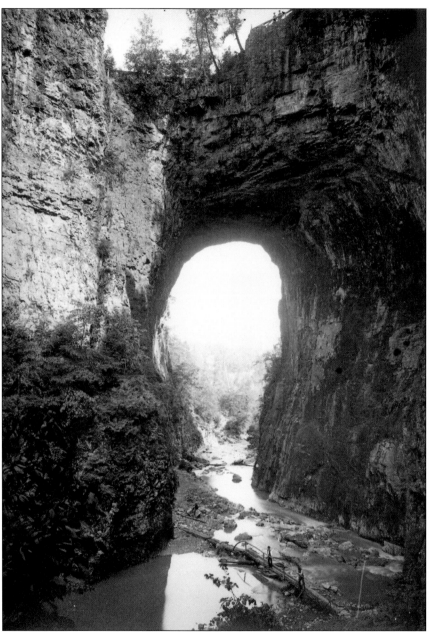

In October 1777, the state legislature of Virginia created a new county. It was called Rockbridge, named for the natural stone bridge within the county boundaries. The bridge is mentioned in the Indian lore of the Monacan tribe as a place to flee from warring tribes. Thomas Jefferson purchased the bridge as part of a land grant from King George III in 1774, and it has been maintained by private owners ever since. It stands 215 feet high and spans 90 feet. In the 1800s, Lexington citizens and students from Washington and Lee University or the Virginia Military Institute took day trips to visit the Natural Bridge. With the invention of the automobile, it became a favorite national tourist destination. (Courtesy of Michael Miley Photograph Collection; Virginia Historical Society, Richmond, Virginia; Special Collections, Leyburn Library, Washington and Lee University.)

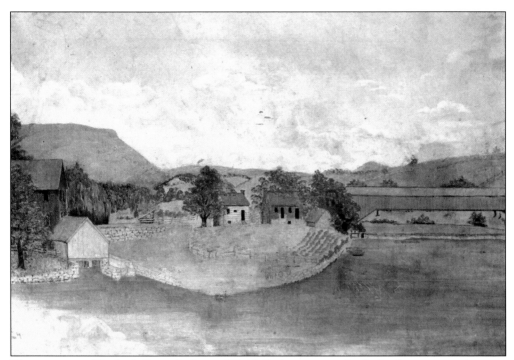

The painting of Jordan's Point, by James Waddell, shows not only the bridge crossing the river and House Mountain, but also the gauge dock for the canal boats. A packet boat was measured against the water level and then was loaded with iron ore bars and measured again to determine the weight of the product to be shipped. (Courtesy of the Rockbridge Historical Society.)

Packet boats came up the James and North Rivers from Richmond. Rockbridge County had iron furnaces, and bars of iron, whiskey, and other products were sent downriver. The tow paths of the North River Navigation Company are still visible, but most of the dams and locks needed to lift the boats up the river are gone. The river's name was changed to the Maury in honor of Commodore Matthew Fontaine Maury, who taught at the Virginia Military Institute after the Civil War. (Courtesy of Rockbridge Historical Society Collection; Special Collections, Leyburn Library, Washington and Lee University.)

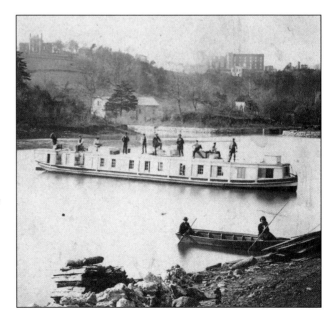

There were a variety of businesses at Jordan's Point. McCorkle and Lusk advertised for sale in the *Lexington Gazette*: "bale cotton, soda, pepper, tobacco, candles, calicoes, Masons Original Blacking, horn buttons, Queensware dishes, nails, molasses lard, Our Own schoolbooks, coffee mills and grain bags, and a wide variety of fabrics." Moses' Mill ground wheat and corn to produce flour and cornmeal. The only surviving building of the industrial community at Jordan's Point is the Miller's House on the left of this view. All the others have disappeared because of floods and aging. Since the point is a flood plain, no new buildings may be constructed there. (Courtesy of Rockbridge Historical Society Collection; Special Collections, Leyburn Library, Washington and Lee University.)

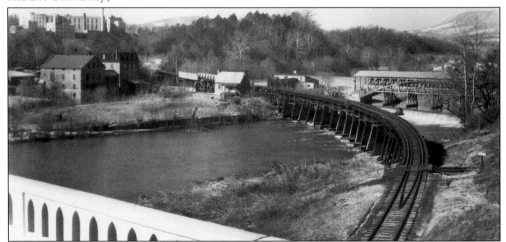

Jordan's Point was a center of transportation from earliest times. Native American tribes canoed the river and walked "the Great Path" when hunting in the valley. Benjamin Borden received a grant that required each of 100 families to settle the land by building a cabin on 100 acres. By 1740, he met these conditions of the Virginia Council and the Native American path became the Great Wagon Road. The canal system developed from Jordan's Point when iron was needed in Richmond. All of the products to and from Lexington went through Jordan's Point. The road changed position slightly and became U.S. Route 11. (Courtesy of Rockbridge Historical Society Collection; Special Collections, Leyburn Library, Washington and Lee University.)

John Jordan, pictured here, came to Lexington in 1796. He was a brick mason and in 1815 formed a construction business with Samuel Darst. In 1818, they built Stono and later the Pines and Beaumont residences on Lee Avenue. In 1822, the trustees of Washington College contracted with Jordan and Darst to erect the center building, named Washington Hall. They introduced the neoclassical style that can be seen in many buildings of Lexington. (Courtesy of VMI Archives.)

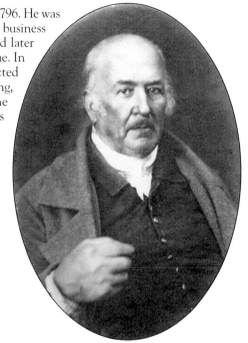

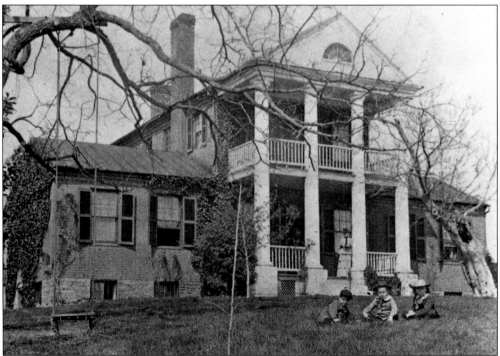

Overlooking Jordan's Point is Stono, the home of John Jordan, a prominent local businessman and builder. Merchandise shipped from Lynchburg, Richmond, and points beyond arrived at the docks below Stono for delivery to the citizens of Lexington. Shown seated on the lawn in 1894 are John Campbell, Jack Rogers, and Ted Barclay. Mrs. L. B. Campbell, who taught the three lads until 1897, is standing on the porch. (Courtesy of VMI Archives.)

The Castle was built on Randolph Street in the 1790s by Andrew Reid and served as a lawyer's office. The county court records were kept here, and because of that, the records were not destroyed in the fire of 1796. (Courtesy of A. T. Williams.)

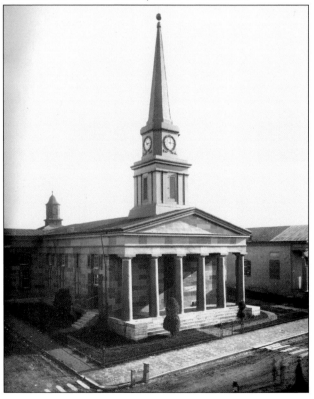

The Lexington Presbyterian Church was organized in 1789. Its predecessor was Old Monmouth Church west of Lexington. The Scotch-Irish, who came from Pennsylvania down the Great Wagon Road, found the valley open to settlement. Religion and education were of utmost importance to these settlers. The church, a fine example of Greek Revival architecture built in 1845, is at the corner of Main and Nelson Streets. (Courtesy of Rockbridge Historical Society Collection; Special Collections, Leyburn Library, Washington and Lee University.)

The Letcher House at 21 University Place (seen from Main Street) was the residence of William H. Letcher. He was the father of the Civil War governor of Virginia, John Letcher. The governor lived next door. When Gen. David Hunter raided Lexington in 1864, his men burned the governor's house. Gov. John Letcher moved into his father's home and lived there for the rest of his life. (Courtesy of Rockbridge Historical Society Collection; Special Collections, Leyburn Library, Washington and Lee University.)

On lower Main Street below Washington and Lee University was located the Blue Hotel, an inn and tavern owned by Jacob Clyce. The structure was built in 1818 and demolished in 1947. The eye (circular window) in the pediment was preserved and is in the Rockbridge Historical Society collection. (Courtesy of William Hoyt Collection; Special Collections, Leyburn Library, Washington and Lee University.)

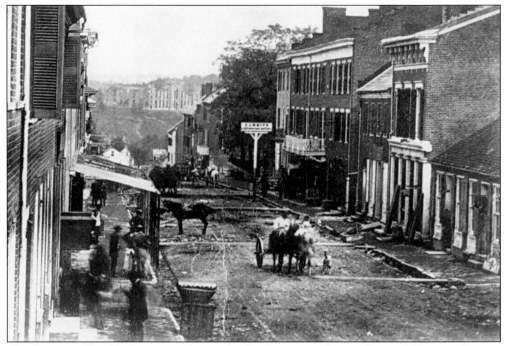

The damage suffered by Lexington during the Civil War is evident in this *c.* 1866 image showing Virginia Military Institute in the background. Nearly all of the men in the town had gone to war, and many did not return. But "War has not wholly wrecked us," wrote Margaret Junkin Preston. "Still Strong hands, brave hearts, high souls are ours; Proud consciousness of quenchless powers." (Courtesy of Rockbridge Historical Society Collection; Special Collections, Leyburn Library, Washington and Lee University.)

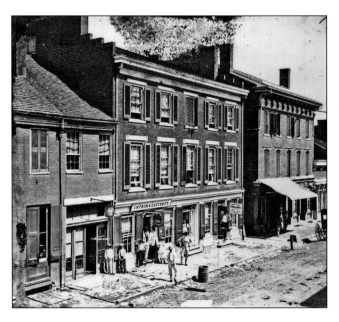

Shoppers on Main Street in the 1870s went to Antrim and Lafferty, where one could purchase dry goods, partly made dress shirts, notions, and hardware. The Old Mansion Spice and Coffee Company was founded at this location in 1877 and relocated by Antrim to Richmond, Virginia, where it still exists today. Note the signs for establishments on either side with the watch and a tobacconist. (Courtesy of Michael Miley Photograph Collection; Virginia Historical Society, Richmond, Virginia; Special Collections, Leyburn Library, Washington and Lee University.)

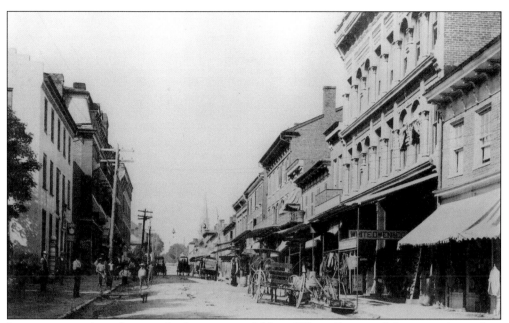

Lawn mowers, plows, hoes, and rakes were available at White Owen and Company, located on Main Street in the block between Nelson and Washington Streets in the 1890s. (Courtesy of Rockbridge Historical Society Collection; Special Collections, Leyburn Library, Washington and Lee University.)

This house on Virginia Military Institute property at 306 North Main Street still serves as a residence. The cupola was removed after a 1952 fire, the steps have been modified, and its Victorian color scheme changed to solid white today. In 1869, D. M. Reilley purchased the land, and Joseph C. Rittenhouse owned it in 1870. His sister, who inherited the house, sold it to VMI in 1946 for $3,511.40. (Courtesy of Rockbridge Historical Society Collection; Special Collections, Leyburn Library, Washington and Lee University.)

African Americans worshipped in the white churches of Lexington until 1867, when the Lexington African Baptist Church was allowed to organize. In 1886, the *Rockbridge County News* reported that "75 converts were baptized in the North River." The church (now named the First Baptist Church) has continued to be a cornerstone of the African American community. The small church to the left was removed when the new church was built on Main Street in 1894. (Courtesy of the Rockbridge Historical Society/First Baptist Church.)

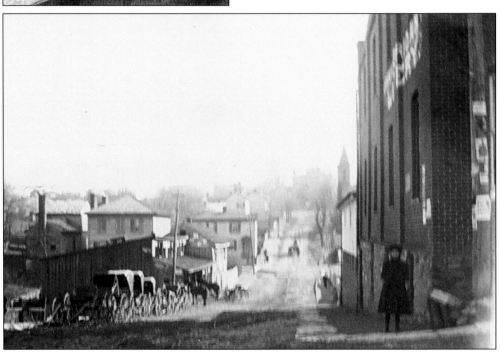

The Sheridan Livery was built in 1887 at 29 North Main Street. John Sheridan operated a stagecoach service from this building. The exterior of the structure has remained unchanged, but its interior has served a variety of purposes. In the 1920s, it was a steam laundry; at the end of the 20th century, it was Old Main Street with small shops. In 1997, it became a hotel and dining room reclaiming its name, the Sheridan Livery. (Courtesy of Rockbridge Historical Society Collection; Special Collections, Leyburn Library, Washington and Lee University.)

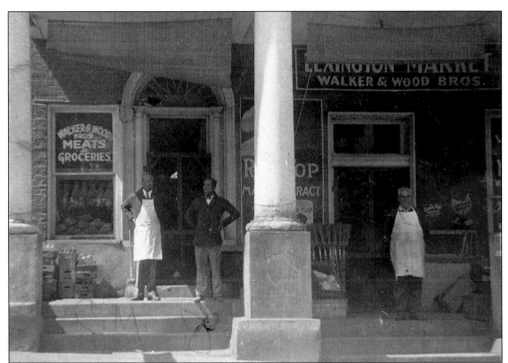

Clarence, Joe, and Harry Lee Walker are standing in front of their store on Main Street. Harry Walker went into business in 1908. He ran a farm on the Old Buena Vista Road and bought cattle from the Swishers in Fairfield. Also cattle were shipped to Buena Vista by train, and Harry Lee had his men drive them to Lexington for slaughter. He cured his own ham and sold that and the beef to the Virginia Military Institute. (Courtesy of Special Collections, Leyburn Library, Washington and Lee University.)

The Walker and Wood Brothers meat store was located at 30 Main Street in the building now known as the Willson-Walker House, built around 1820. After the Civil War, the lower (north) end of Main Street had a number of prosperous African American merchants. The building is now a restaurant. (Courtesy of Special Collections, Leyburn Library, Washington and Lee University.)

19

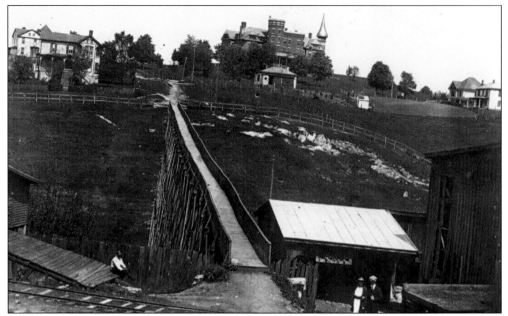

DeHart Hotel, Lexington's boom hotel built in 1891, and its golf course stood on what is now known as Castle Hill above the train depot. The hotel was lost to fire in 1922. The structure also served as housing for Washington and Lee University men. (Courtesy of Rockbridge Historical Society Collection; Special Collections, Leyburn Library, Washington and Lee University.)

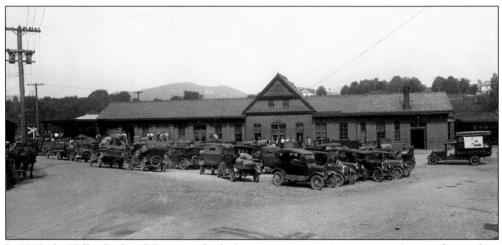

In 1883, the Valley Railroad Company built the train station in Lexington in hopes of extending the tracks to Salem, Virginia. The line south was never completed. The tracks to the station were in use until 1969, when a flood destroyed the Maury River trestle. Later the old station was moved one block south to make room for Wilson Hall, an addition to the Lenfest Center for the Arts on the Washington and Lee University campus. (Courtesy of Michael Miley Photograph Collection; Virginia Historical Society, Richmond, Virginia; Special Collections, Leyburn Library, Washington and Lee University.)

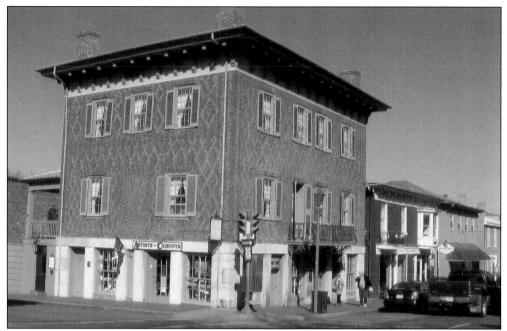

The Alexander-Withrow House is located on the corner of Main and Washington Streets. The roadbed originally came to the brick level of the house; however, because of the steepness, Main Street was lowered in 1851, exposing the foundation of the house. The glazed header bricks form a decorative pattern on the walls of the building. It was built in 1789 by William Alexander, who used it as a residence and a store. The street level is currently occupied by Artists in Cahoots. (Courtesy of A. T. Williams.)

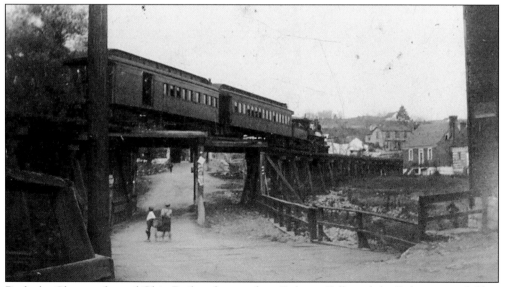

Both the Chesapeake and Ohio Railroad trains from Balcony Falls and the Baltimore and Ohio trains from Staunton backed into Lexington by crossing the river on trestles at Jordan's Point. The bridge abutments for the longer trestle are still visible in the water, and a segment of the trestle by the Miller's House is preserved to illustrate some of the history of Jordan's Point. (Courtesy of VMI Archives.)

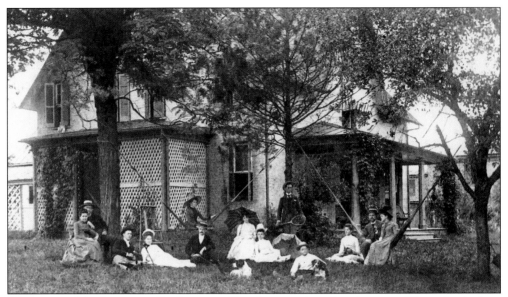

The manse of the Lexington Presbyterian Church was a place for relaxation. The individuals in this c. 1888 photograph are, from left to right, Lucy Waddell Preston and Thomas L. Preston, Reid White, Kitty Houston, Leslie Campbell, Daisy Preston (in the hammock), Lizzie Preston, Lucy Preston, Jack Johnstone (standing with racquet), Nettie Preston, Willy Preston and Sally Preston (in hammock), and John Preston (with dog). (Courtesy of Rockbridge Historical Society Collection; Special Collections, Leyburn Library, Washington and Lee University.)

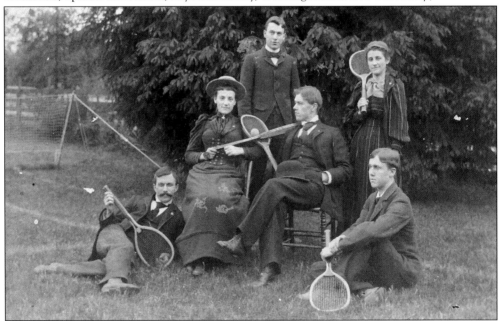

Washington and Lee University student Clifford Sperow (third from left), from Martinsburg, West Virginia, joined several Lexingtonians for tennis in May 1893. Around him from left to right are Sandy Figgatt, Lucy Pendleton, Glasgow Armstrong, Sue Pendleton, and J. B. Bullitt. They are shown at the Pines, a residence on the corner of Lee Avenue and Preston Street. Sperow became a physician. (Courtesy of Special Collections, Leyburn Library, Washington and Lee University.)

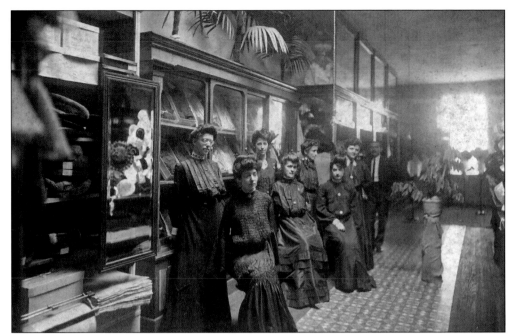

The personnel of Weinberg's store on Main Street (photographed in 1904) are ready to assist customers. From left to right are Louise Illig, Rebecca Weinberg, Grace Klicker, unidentified, Fanny Boley, Fanny Meeks, Rosa Boehm, and Isaac Weinberg. In 1909, their *Lexington Gazette* advertisement listed ladies shoes for 98¢ and men's wool suits for $2.98. (Courtesy of Rockbridge Historical Society Collection; Special Collections, Leyburn Library, Washington and Lee University.)

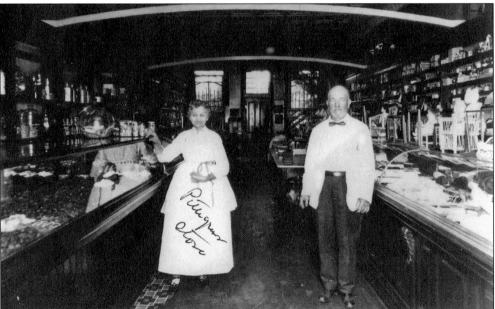

Mr. and Mrs. Joseph Pettigrew ran a shop on Washington Street that offered a wonderful assortment of candies as well as toys and gifts. Joseph Pettigrew also did custom picture framing. (Courtesy of Rockbridge Historical Society Collection; Special Collections, Leyburn Library, Washington and Lee University.)

A building known as Franklin Hall once stood on the corner of Jefferson and Nelson Streets. Franklin Hall housed the library of the Franklin Society. They rented part of the building to the local Masonic chapter, a private school operated there, and Judge John W. Brockenborough offered a law class in the building. In 1915, the hall was destroyed by fire. The new building was occupied by Robinson Supply Company in 1917. Later it was the location of Harper and Agnor and then an antique business. The Palms restaurant currently occupies the building. (Courtesy of WPA Collection; Special Collections, Leyburn Library, Washington and Lee University.)

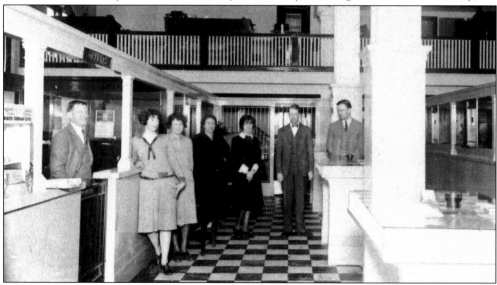

The Rockbridge Bank on the corner of Main and Nelson Streets offered banking services, with a helpful staff in the 1930s pictured here. From left to right are Andrew Wade, Marion Jones, Peggy Wade, Mabel Adair, Louise Tyree, Lloyd McClung, and Dorsey Hopkins. (Courtesy of Mary Frances N. Cummings.)

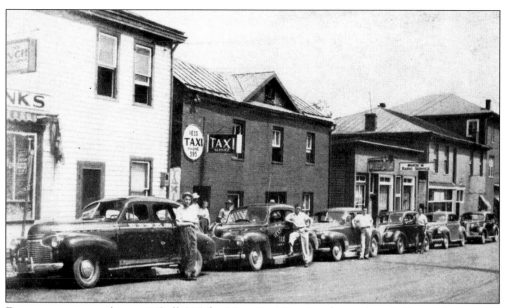

Does someone need a taxi? Call 395 for Vess Taxi Service, located on Jefferson Street. All passengers are insured; cars are equipped with radio and heat; and taxis are available 24 hours a day. (Courtesy of Dan Coffey.)

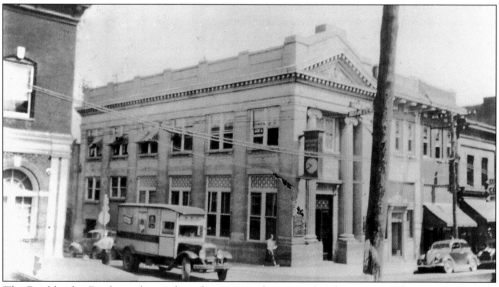

The Rockbridge Bank was located on the corner of Main and Nelson Streets diagonally opposite the Lexington Presbyterian Church. The photograph shown here was made in 1937 as part of the Works Progress Administration (WPA) survey. (Courtesy of WPA Collection; Special Collections, Leyburn Library, Washington and Lee University.)

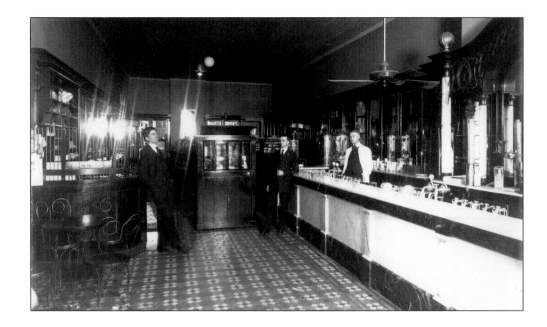

McCrum's drugstore, an establishment that lasted for over a century, was located at 17 South Main Street. In the photograph above, owner Cleveland Davis is pictured at the left. McCrum's was an integral part of the social life of Main Street by providing a soda fountain and bus depot. From 1935 until the mid-1940s, McCrum's provided free ice cream for participants in the Fourth of July Parade; this amounted to 1,500 cups one year. (Both courtesy of Rockbridge Historical Society Collection; Special Collections, Leyburn Library, Washington and Lee University.)

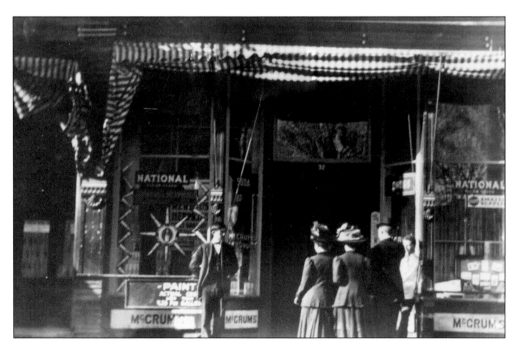

Gorrell's drugstore, established by Benjamin Gorrell, a former Confederate soldier from Culpeper, was first located on Washington Street around 1868, then on Main Street, and at 17 West Nelson Street as seen here. At the latter location, it became Rice's and the State drugstore across from the State Theatre. The original store included a bookstore, and the later stores featured soda fountains. The State drugstore was a popular hangout for teenagers in the 1940s and 1950s. (Courtesy of Special Collections, Leyburn Library, Washington and Lee University.)

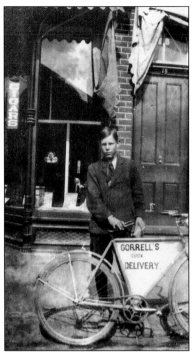

McCoy's Grocery, on the corner of Washington and Jefferson Streets, sold Virginia hams and always had one hanging in the window. Alvin Carter and Dennis Dixon bought the property in 1963 and opened a men's clothing store (Alvin-Dennis) catering to Washington and Lee University students. A change was made in the mid-1980s when women were admitted to W&L; the store office became the women's department. (Courtesy of Alvin Carter.)

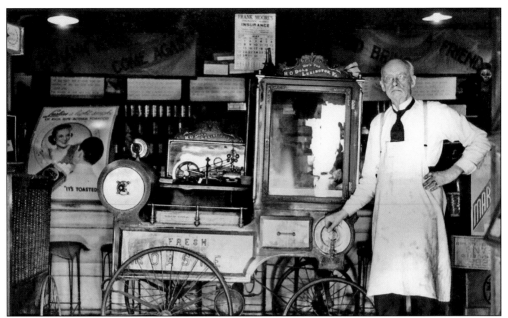

H. O. Dold offered fresh roasted peanuts at his pharmacy located at the corner of Main and Washington Streets. George C. Marshall recalled that as a cadet he went uptown on Saturday afternoon to Dold's store: "He was quite a character and made a great point of favoring the cadets." The white apron was his trademark. (Courtesy of Rockbridge Historical Society Collection; Special Collections, Leyburn Library, Washington and Lee University.)

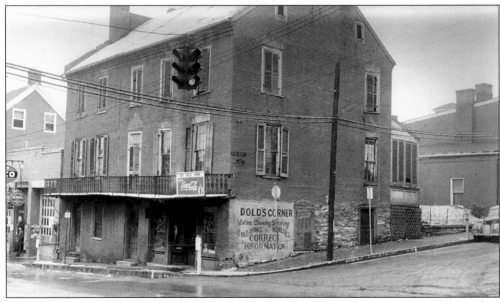

The Dold Building (photographed in 1934) had changed hands but was still a pharmacy late into the 20th century, when it was called Bierer's Pharmacy. The wall sign, which read "Bierer's," was painted over for the movie *Sommersby* when filming took place on this corner. (Courtesy of Bierer's Pharmacy.)

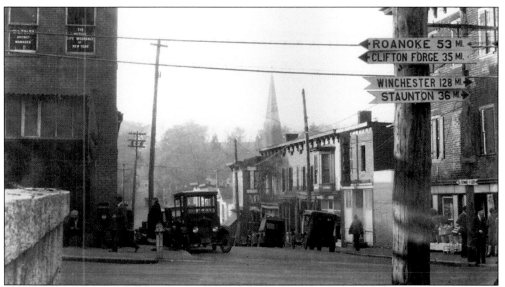

This 1928 westward view from Main and Washington Streets shows how the town of Lexington remains unchanged through the years. The electric and telephone wires have come and gone, but the cornices on the buildings have been lovingly preserved. The spire of the Robert E. Lee Memorial Episcopal Church is seen in the background. (Courtesy of William Hoyt Collection; Special Collections, Leyburn Library, Washington and Lee University.)

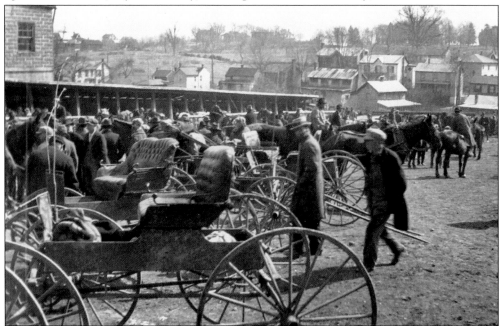

This 1925 photograph was taken on Horse Trade Day at the hitching yard on Randolph Street, where horses were traded or sold on the first Monday of each month, which was also Court Day. On the left is the blacksmith's shop; today the structure houses a blacksmith shop and the Lexington Carriage Company, offering carriage tours to Lexington tourists. The hitching yard is today a parking lot for cars and trucks. (Courtesy of William Hoyt Collection; Special Collections, Leyburn Library, Washington and Lee University.)

Henry Boley, the author of *Lexington in Old Virginia*, started in the book business at an early age by assisting W. C. Stuart, an owner of the Book Store located farther north on Main Street across from the courthouse. At Stuart's death, Boley continued to run the business for the Stuart family until he and a partner bought the business. In 1945, it moved to this location under the ownership of Frederick Fitzgerald. (Courtesy of Andre Studio.)

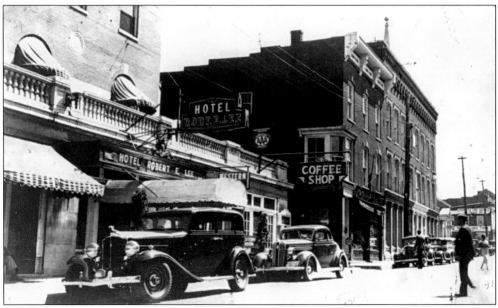

The Robert E. Lee Hotel stands grandly on Main Street in this 1940s photograph. While the structures and names changed over the years, the location had always been a hotel; the Irving Hotel and National Hotel preceded the Lee Hotel there. Beyond the hotel, one views the McClelland house and another building that housed the A&P grocery store and later the Sears store. These buildings were replaced by a Texaco service station. (Courtesy of Mary Frances N. Cummings.)

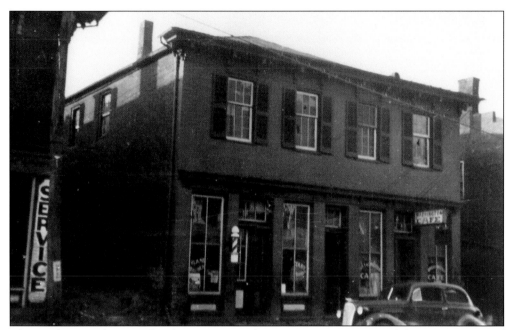

This mid-1930s photograph taken at 16 North Main Street was part of the WPA survey of Lexington performed by James W. McClung. The Washington Café, a popular African American eatery, was operated by sisters Estelle Washington and Edna Washington Lyle. Franklin's Barber Shop was operated by longtime barber Charles Henry Franklin. Franklin taught his trade to his daughters, and Theodora Franklin DeLaney Morgan continued to operate the barbershop after her father's death in 1952. (Courtesy of WPA Collection; Special Collections, Leyburn Library, Washington and Lee University.)

The building at the corner of East Washington and Randolph Streets, across from the Rockbridge Historical Society, was originally a tavern for the Irving Hotel. In the 1950s, the building was used as a schoolbook repository and has served as a yarn shop, a lawyer's office, and now as a restaurant called the Red Hen. (Courtesy of WPA Collection; Special Collections, Leyburn Library, Washington and Lee University.)

These two residences once stood at the south corner of McDowell and Main Streets. Through the trees, one of the columns of the W. W. Coffey Apartments, then under construction, can be seen. Once the apartment building was completed, the two houses were removed. The elderly owners of one of the houses had been promised one of the new apartments, rent free, for the rest of their lives. During World War II (when the Coffey Apartments were built), materials for private construction were difficult to obtain; conveniently, W. W. Coffey had been hired to demolish the old hotel at Rockbridge Alum Springs, and he was able to salvage much of what he needed (including the main staircase) from that structure. (Both courtesy of Dan Coffey.)

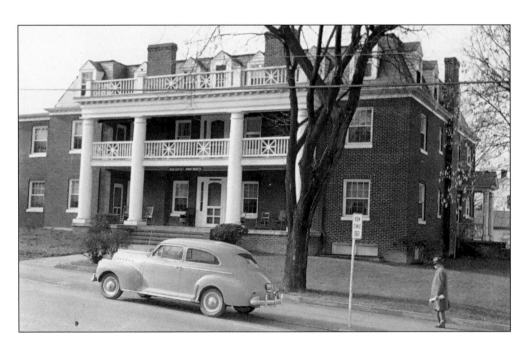

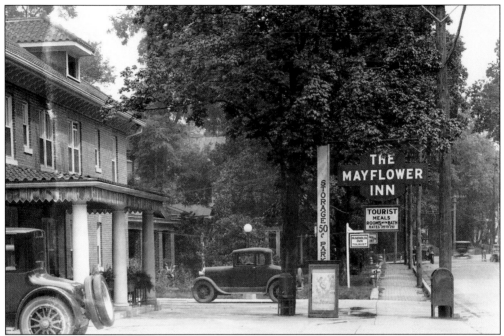

The Mayflower Inn on Main Street was the first facility designed especially for the automobile traveler. The building had a parking garage and originally featured a stained-glass awning around the porch and an illuminated sign. This photograph from 1931 shows that *Buck Jones* was featured at the movie theater. Note the number of tourist homes lining Main Street during the Depression years. The Mayflower was expanded and the facade remodeled a few years later with a columned portico resembling the later W. W. Coffey Apartments. (Courtesy of Dan Coffey.)

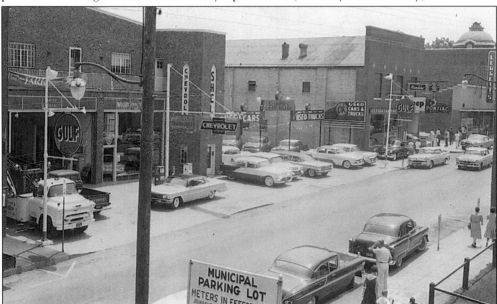

The Woody Chevrolet dealership is shown in the 1960s. When the dealership moved from Main Street, the building was remodeled to house the Rockbridge Regional Library. The library had been in a small house near the Stonewall Jackson Cemetery. (Courtesy of Woody Chevrolet.)

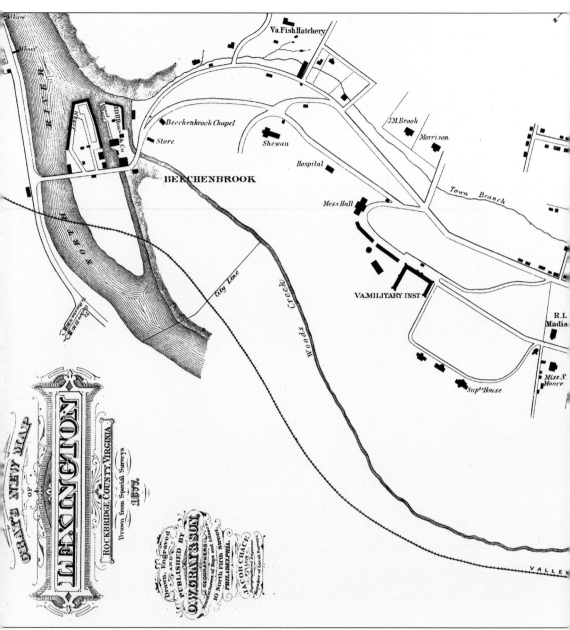

VA.Fish Hatchery

Beechenbrook Chapel

Store

J.M.Brook

Morrison

Shewan

Hospital

BEECHENBROOK

Town Branch

City Line

Mess Hall

Woods Creek

VA.MILITARY INST.

R.L
Madis

Sup'ts House

Miss S.
Moore

GRAY'S NEW MAP
OF
LEXINGTON
ROCKBRIDGE COUNTY, VIRGINIA.
Drawn from Special Surveys
1877.

Drawn, Engraved and
PUBLISHED BY
O.W.GRAY & SON
GEOGRAPHERS.
Manufacturers of Maps and Atlases.
10 North Fifth Street,
PHILADELPHIA.
JACOB CHACE
C.W.G.
Superintendent Engravers.
Manufacturer of Local Surveys.

VALLEY

Gray's New Map of Lexington was drawn by Jacob Chace and published in 1877 by O. W. Gray

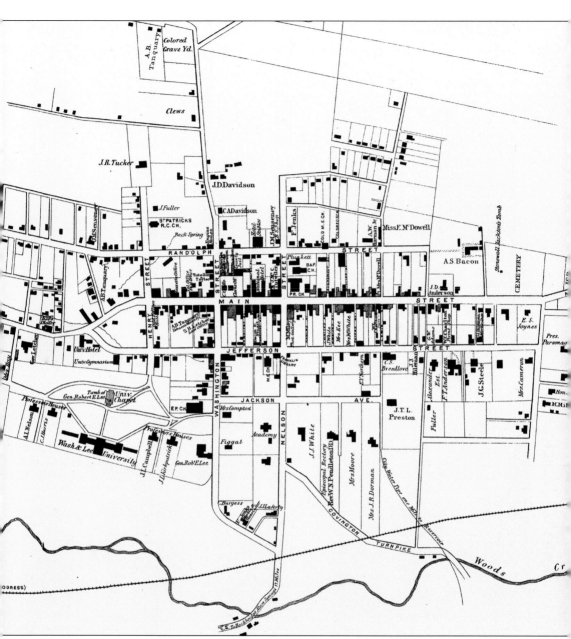

and Son of Philadelphia. (Courtesy of the Rockbridge Historical Society.)

35

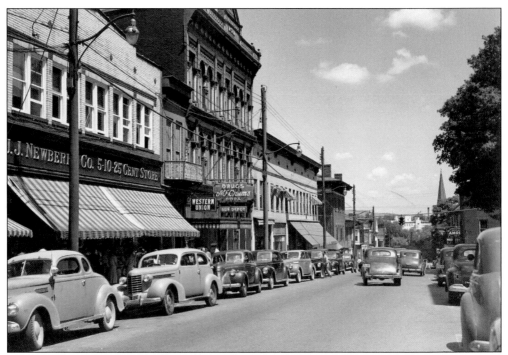

Automobiles fill Main Street during the 1940s. J. J. Newberry Company was an "everything store," unlike some of the individual shops of earlier times. The Virginia Military Institute is in the distance, and behind it is the hill from where Hunter's cannon shelled Lexington during the Civil War. (Courtesy of Rockbridge Historical Society Collection; Special Collections, Leyburn Library, Washington and Lee University.)

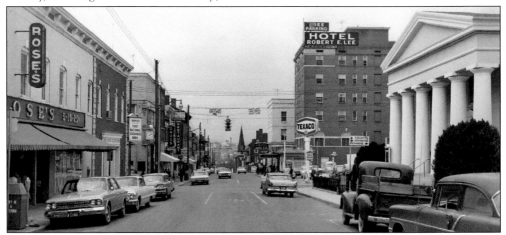

The Rose's store, Main Street parking meters, and two-way traffic signify the 1960s. On the left side looking north, the popular Southern Inn Restaurant, which the Macheras family had operated since 1932, is in view. When later rules concerning signage in the historic business district were implemented, the Southern Inn was allowed to keep its unique neon sign. When Main Street became one way, routing traffic north, parallel Jefferson Street was made one way south. The steeple of First Baptist Church is seen to the right, and VMI is clearly straight ahead. (Courtesy of Rockbridge Historical Society Collection; Special Collections, Leyburn Library, Washington and Lee University.)

Two

COMMUNITY

Strong hands, brave hearts, high souls are ours.

—Margaret Junkin Preston

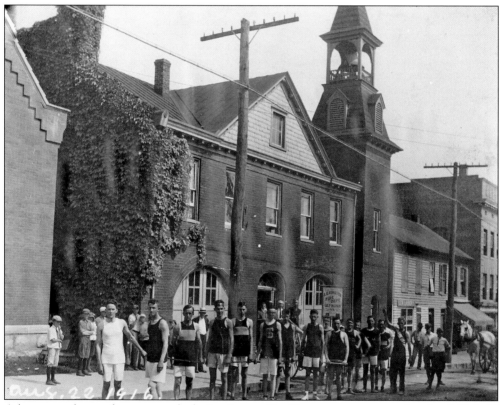

A large crowd turned out to watch the Lexington Fire Department compete in relay drills held in August 1916 in front of the firehouse located on Main Street. The bell in the tower rang the alarm and signaled by count, indicating the section of town where the fire was blazing. At the far left edge stands the Trinity Methodist Church, an earlier building (1890s–1927) located at the same site as the current one. To the right of the firehouse, the frame building (once a residence) is a Chinese laundry, and the large brick building is the Sheridan Building, which housed the Lyric Theatre and retail shops. The fire department, schools, churches, music, and the arts are essential to the community. In this chapter are some of the activities pursued and enjoyed by its people. (Courtesy of Skip Hess.)

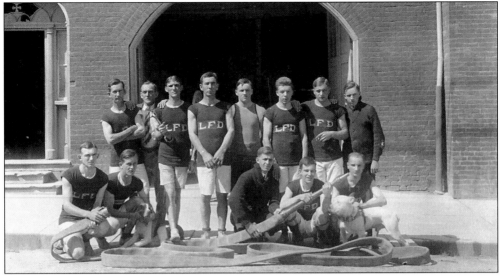

The first severe fire in Lexington was in 1796 when a fire spread through the 20-year-old town. It destroyed the courthouse and over 100 structures, leaving just a few remaining. The Castle and the Alexander-Withrow House were left standing. The Lexington Fire Department provided a vital community service. Here the company pauses for a photograph with mascots in front of the firehouse on Main Street during a training exercise. (Courtesy of Skip Hess.)

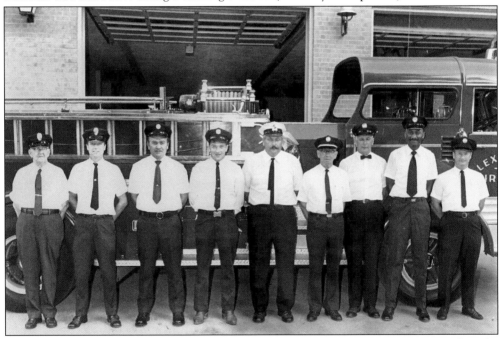

The Lexington Fire Department has moved from Main Street, where there were two bays for fire equipment, to Jefferson Street into a Quonset hut and later enlarged facility, and then to the current location, a large and new firehouse on South Main Street, where there are six bays. This photograph was taken at the Jefferson Street firehouse. Fire and rescue services are staffed by several dozen volunteers, and being a fireman in Lexington is a family affair with a long and strong tradition. (Courtesy of the Lexington Fire Department.)

A fire was discovered in the roof of the Lexington Presbyterian Church midmorning on July 18, 2000, and the fire spread quickly in the timber-framed roof of the 1840s structure. A Lexington *News-Gazette* photographer made this dramatic picture from a nearby building. It shows fire-fighting units from Lexington, Buena Vista, and Staunton. They worked through the day to prevent spreading of the fire to other properties. The only significant damage was to the church sanctuary. (Courtesy of the *News-Gazette*.)

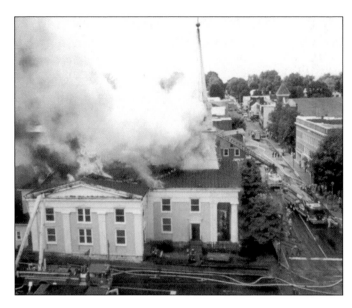

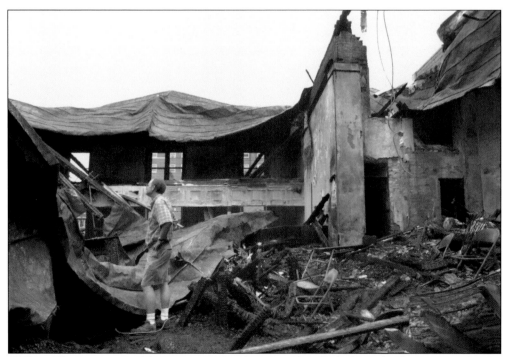

William Klein, minister of the Lexington Presbyterian Church, looks at the destruction after the fire in July 2000. The church was rebuilt much as it was before the fire but with stronger beams, a new pulpit area, and a C. B. Fisk organ. (Courtesy of the *Roanoke Times*.)

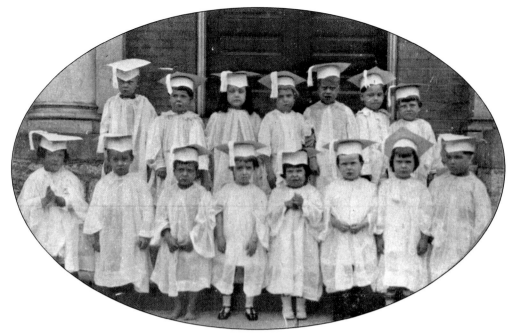

Fifteen toddlers participate in the Children's Day Exercises held at the Lexington Presbyterian Sabbath school on May 28, 1922. (Courtesy of Lexington Presbyterian Church.)

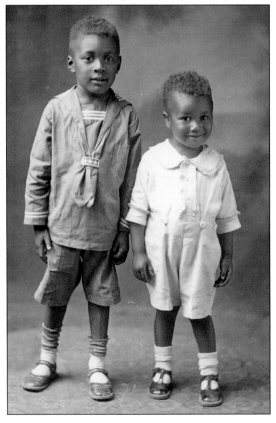

Michael Miley captures the adorable Borgus brothers. (Courtesy of Michael Miley Photograph Collection; Virginia Historical Society, Richmond, Virginia; Special Collections, Leyburn Library, Washington and Lee University.)

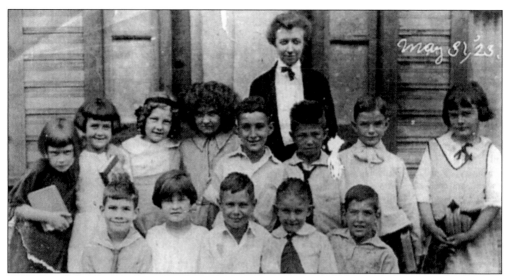

Second and third graders with Edmonia Smith are seen here at her school, which was held in the Dutch Inn on Washington Street at the time of this photograph in May 1923 and later at her home on Jackson Avenue. Edmonia, granddaughter of Supt. Francis H. Smith of VMI, taught several generations of local families. (Courtesy of Mary Frances N. Cummings.)

These children in front of Ann Smith School (1930s) would have attended there sometime after 1927, when Lexington High School moved to the new Sarah's Run site. Ann Smith remained the location for the lower grades until 1970, when it was incorporated into Waddell Elementary School. (Courtesy of Rockbridge Historical Society Collection; Special Collections, Leyburn Library, Washington and Lee University.)

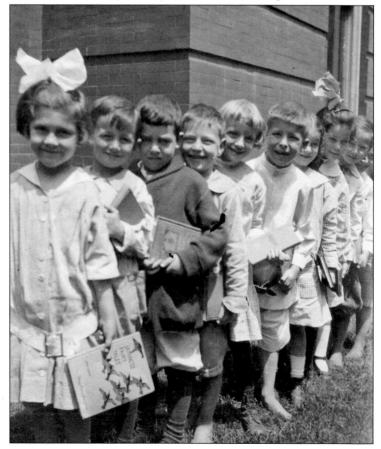

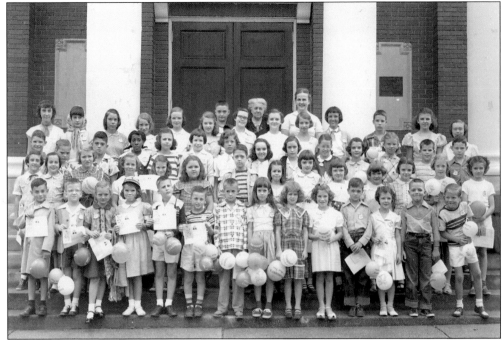

Children participating in the Rockbridge Regional Library summer book club (around 1953) pose with librarian Madeline Willis (back row, center) in front of the Manly Memorial Baptist Church, across from the library in the Huffman Insurance Building. The Lexington Public Library was housed at various locations on Main Street during the 1930s and early 1940s. In 1944, the Junior Woman's Club requested funds for municipal housing, but the town council allotted only $20. Under the leadership of Elizabeth E. Munger, the Junior Woman's Club spearheaded an effort resulting in the formation of the Botetourt-Rockbridge Regional Library, bringing support of $10,000 from the state in 1946. (Courtesy of David Coffey.)

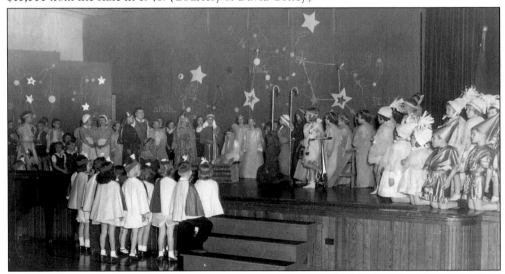

Tom Barrett, minister of the Robert E. Lee Memorial Episcopal Church, enjoyed writing plays. The *Christmas Story* was written for the children of Ann Smith School in the mid-1950s. Notice the authenticity of the star location in the backdrop. (Courtesy of David Coffey.)

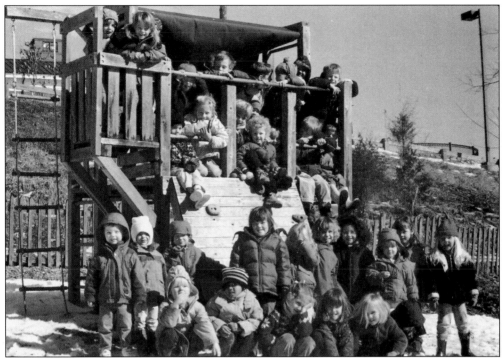

Students from the Woods Creek Montessori School stop for a moment from playing at their school nestled on the hillside above Woods Creek. Portions of Washington and Lee University campus are seen in the background. (Courtesy of Woods Creek Montessori School.)

This frame structure was adjacent to the present Randolph Street Methodist Church, where it served as an African American schoolhouse from 1865 until the 1920s. It was originally constructed in 1819 to serve as a white academy. (Courtesy of the Jackson Davis Collection, Special Collections, University of Virginia Library.)

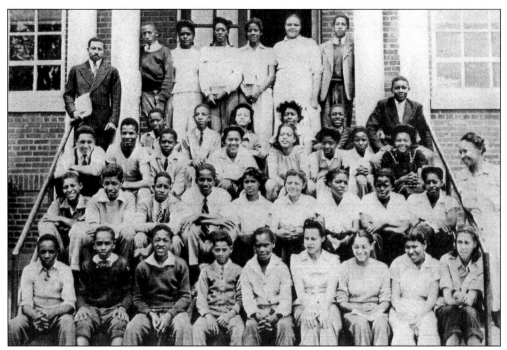

Students pose in front of Lylburn Downing School in 1946. Pictured from left to right are (first row) Glasgow Pleasants, Edward Poindexter, unidentified, Beecher Waugh, unidentified, Famie Winters Smothers, Doris Harris, Christine Randolph, and Fayetta Fielding; (second row) Jerry Roane, William Johnson, Sammy Watts, unidentified, Doris Jones Porterfield, Julia Ann Styles, Rosa Mack Wiggins, Barbara Ann Gooch, and Julia Rae Beale; (third row) Alexander Wood, Bobby Richardson, unidentified, Betty Jones Massie, Eloise Walker Johnson, Frances Turner, Julia Kyle, and Nellie Thompson; (fourth row) unidentified, Leander J. Shaw Jr., Primrose Winters, Fannie Turner Thompson, Wendell Fitz, and unidentified; (fifth row) Leroy Tiny Richardson, John Wesley Hall, Connie Craney Poindexter, Janey Mae Beale Carter, Margaret Brooks, Hallie Bell Nash, and Payne Poindexter. The teacher is Laura Etta Price Gilmore Rucker. The school became a middle school, as it is today, in 1961. (Courtesy of Wood Collection; Special Collections, Leyburn Library, Washington and Lee University.)

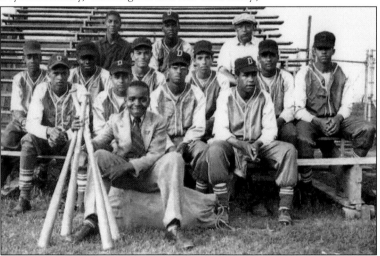

Members of the Lylburn Downing baseball team pose for the photographer in 1949. (Courtesy of Rockbridge Historical Society Collection; Special Collections, Leyburn Library, Washington and Lee University.)

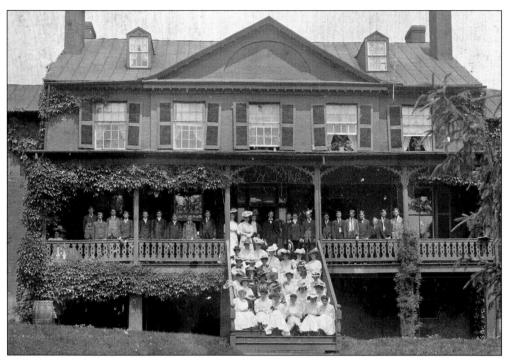

The Female Academy was organized in 1807 and opened in 1809 under the leadership of Ann Smith, for whom it was later named. It continued in this structure for approximately 96 years until it became Lexington High School in 1903, located at the northwest corner of Nelson Street and Lee Avenue. (Courtesy of Rockbridge Historical Society Collection; Special Collections, Leyburn Library, Washington and Lee University.)

Students and faculty of Lexington High School are shown here on the steps of the Ruffner building on East Washington Street (present site of Lexington City Hall) in 1898. Harrington Waddell (top right by doorway) served as principal from 1897 to 1943. (Courtesy of Rockbridge Historical Society Collection; Special Collections, Leyburn Library, Washington and Lee University.)

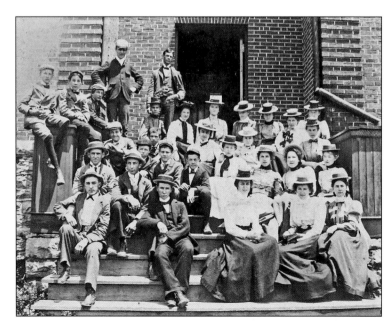

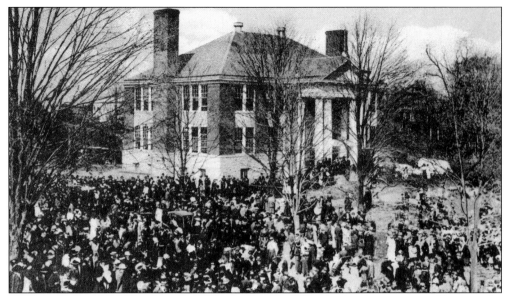

The former building for Ann Smith Academy was replaced by this brick structure and became the Lexington High School in 1903, continuing through 1927 when the new high school was built on 100 Pendleton Place. This photograph shows a school fair held about 1905 to build support for better public schools. The facility became an elementary school for a period of time and is currently a fraternity house for Washington and Lee University. (Courtesy of David Coffey.)

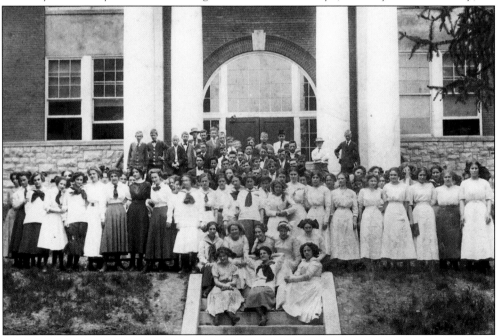

In 1910, students at the Lexington High School gather in front of the building at the corner of Nelson Street and Lee Avenue. It continued as the high school until it moved to a new building on Sarah's Run (Woods Creek), the present location of Waddell Elementary School. (Courtesy of Rockbridge Historical Society Collection; Special Collections, Leyburn Library, Washington and Lee University.)

Built in 1927, this facility housed Lexington High School until 1960. With the move to a new facility (currently Maury River Middle School), Rockbridge High School was established and this building became Waddell Elementary School, including students from Ann Smith Elementary in 1970. (Courtesy of Rockbridge Historical Society Collection; Special Collections, Leyburn Library, Washington and Lee University.)

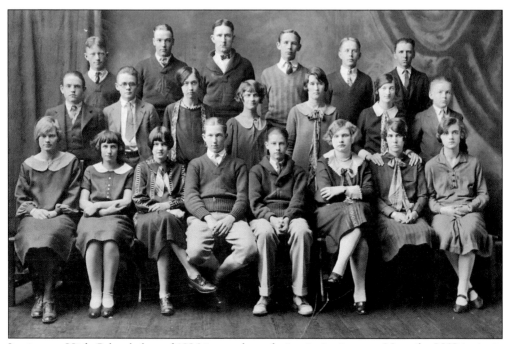

Lexington High School class of 1926 is seen here during its junior year. Note the LHS insignia on the sweaters of several young men. (Courtesy of Mary Frances N. Cummings.)

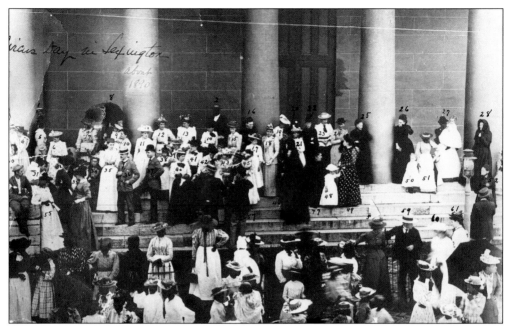

When the circus came to town (around 1890), Michael Miley may have taken this photograph of a group waiting for the parade on the steps of Lexington Presbyterian Church. Miley's studio was located in the building across the street. (Courtesy of Rockbridge Historical Society Collection; Special Collections, Leyburn Library, Washington and Lee University.)

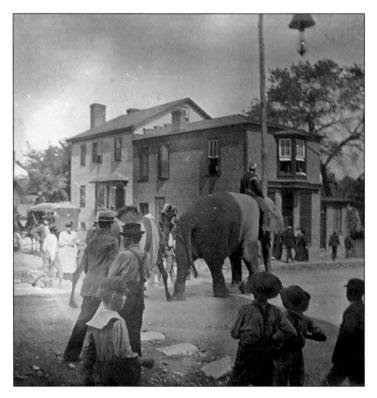

During a c. 1896 circus parade, children and adults gather to watch an elephant and camel stroll down Main Street. The building in the rear is McKemy's Grocery at the corner of Main and Henry Streets. (Courtesy of Rockbridge Historical Society Collection; Special Collections, Leyburn Library, Washington and Lee University.)

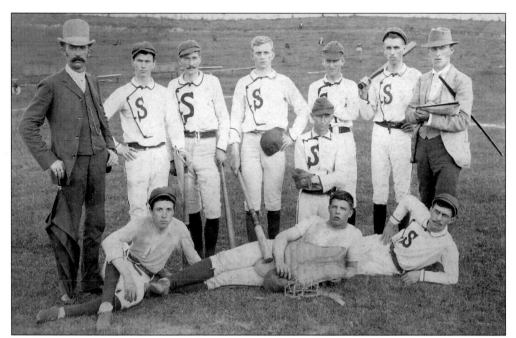

The Stonewall Baseball Club, semi-professional team for Lexington, is shown here during a game played in July 1888 at Staunton. The members of the team (identified by last name) are, from left to right, (first row) Bolling (pitcher), Freeland (catcher), and Figgat (shortstop); (second row) Barclay (manager), Letcher (captain and second base), Varner (right field), Darst (center field), Smith (kneeling; first base), Morrison (left field); Laird (third base), and F. Morrison (scorer). (Courtesy of Rockbridge Historical Society Collection; Special Collections, Leyburn Library, Washington and Lee University.)

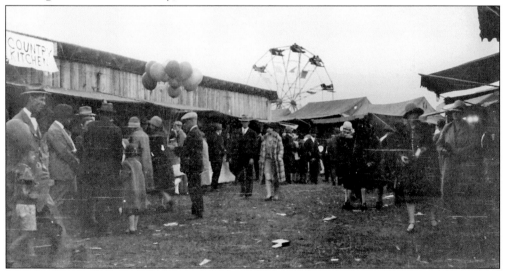

By 1927, the county fair was more entertainment than agricultural competition, as seen here with balloons, vendors, and Ferris wheel in the background. This photograph was taken when the fair was held at the grounds adjacent to Taylor and Wallace Streets, currently named Brewbaker Field. (Courtesy of William Hoyt Collection; Special Collections, Leyburn Library, Washington and Lee University.)

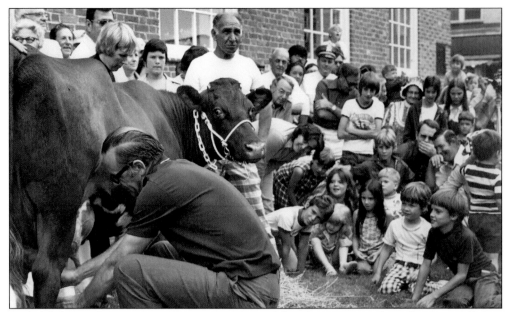

Each fall during the Lexington Community Festival, booths are set up along the center of Main Street, where local artisans and nonprofit groups rent space to show their wares. One year, a challenge was issued to determine which of the community leaders was best at milking a cow. Mayor Charles Phillips practiced the summer before the event, but his cow would not cooperate when it came time to fill the bucket. (Courtesy of Charles Phillips.)

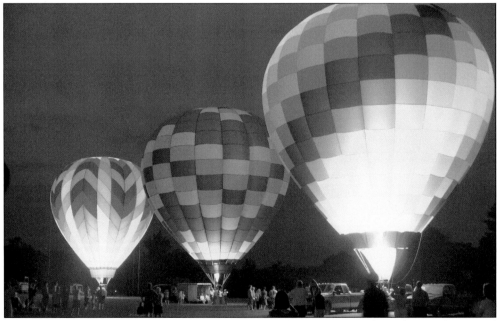

The balloon glow coupled with a massive fireworks display is a spectacular ending to the annual Fourth of July Balloon Rally, held on the Virginia Military Institute parade ground. Begun in 1997, the event includes music, food, games, and hot air balloon rides. Following the last balloon flights of the day, balloons are anchored and inflated, and the flames create a spectacular glow. (Courtesy of Charles Pearson.)

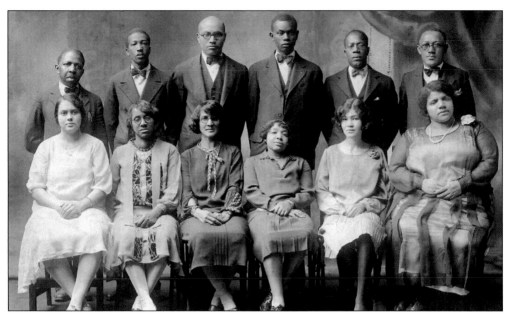

The Nightingales were a popular singing group in Lexington during the 1930s. The members of the group are, from left to right, (first row) Nannie Wood, Kissie Banks, Eliza Walker, Leana Clark, Gladys Washington, and Daisy Evans; (second row) Perry Robinson, Lewis Richardson, Clarence Wood, Ira Hawkins, Al Morrison, and William Dock. A favorable review of a concert held in the Lexington High School auditorium said, "The principal part of the program was devoted to the singing of Negro Spirituals and was sacred music; some of it deeply devotional." (Courtesy of Wood Collection; Special Collections, Leyburn Library, Washington and Lee University.)

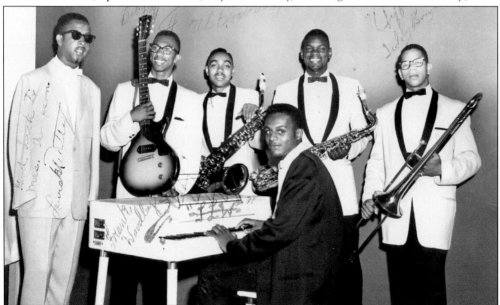

The Rhythm Makers often performed at special events in the Lexington area. The group's members were, from left to right, Lewis Watts, Billy Huffman, U. V. Broadneaux, Frank Woodly at the keyboard, Sticks Thompson, and Napoleon Borgus. (Courtesy of Rockbridge Historical Society Collection; Special Collections, Leyburn Library, Washington and Lee University.)

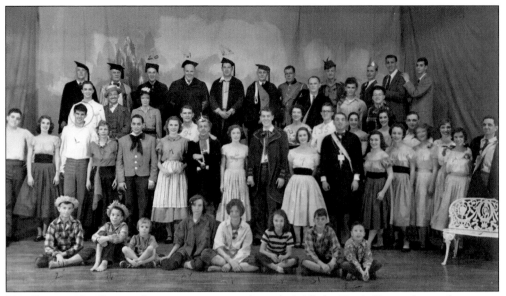

Tom Barrett, the Episcopal minister, wrote a play titled *All the King's Horses* for production in 1952 on the Waddell High School stage. The cast members included faculty members and their spouses, students, and townspeople. On the far right is Marshall Fishwick, the author of *General Lee's Photographer*. (Courtesy of Katie Letcher Lyle.)

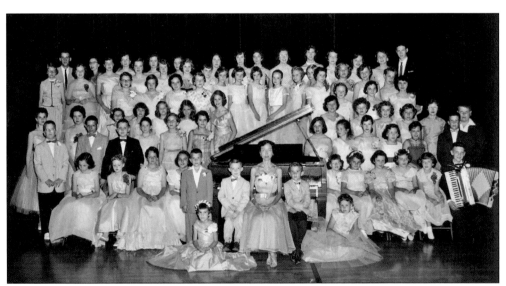

In the 1950s, many piano students attended classes taught by Mary Virginia McCoy Scott. Each recital at Waddell High School consisted of a procession across the gym floor. In order to keep the program at an acceptable length, many of the performances were duets, trios, or even quartets. (Courtesy of David Coffey.)

Mary Monroe Penick graduated from Hollins College in 1926, where she was "Queen of the May" (shown here) and class president. An accomplished musician, she attended Julliard School and studied in Paris with Nadia Boulanger. As organist at Lexington Presbyterian Church for 44 years, she was the center of the Lexington music scene. Her friendship with Howard Mitchell, director of the National Symphony Orchestra (NSO) of Washington, D.C., resulted in annual Lexington concerts by the NSO. Each one-day visit included a program for schoolchildren and an evening concert. She also established the Rockbridge Concert-Theatre Series, which for over 35 years presented professionally produced music and stage shows. (Courtesy of Hollins University.)

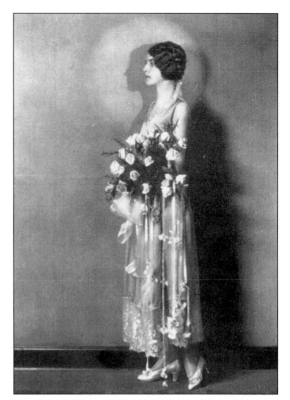

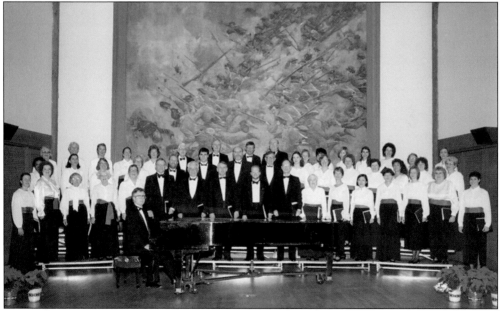

Fine Arts In Rockbridge (FAIR) was organized in 1971 under the leadership of Charlene Jarrett. FAIR started as a summer workshop in music, art, drama, and dance for children. The program grew to include adults and placed teachers into the public school system. The Rockbridge Choral Society (RCS), shown here, is one of the groups that make up FAIR. At the piano is William McCorkle, director of the RCS. (Courtesy of Fine Arts in Rockbridge.)

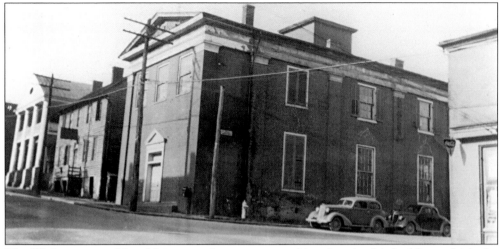

The Washington and Lee University theater presented its plays in this building, which the university purchased in 1929, called the Troubadour Theatre. It was built in 1853 as a meeting place for the Odd Fellows but was used as a community meeting place for diverse groups. The lower floor served as a shoe factory, hardware store, opera house, and nickelodeon. When the building beside it was demolished, the uproar over the removal led to the formation of the Rockbridge Historical Society in 1939. (Courtesy of WPA Collection; Special Collections, Leyburn Library, Washington and Lee University.)

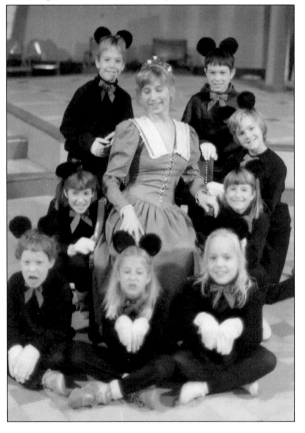

There is a strong connection between Washington and Lee University and University College, Oxford. Thus some English traditions were carried to Lexington. At Christmas, Al Gordon, director of the fine arts department, produced pantomimes as done in England. Here Keltie Hays is shown with her mice in the story of *Cinderella*. (Courtesy of Al Gordon.)

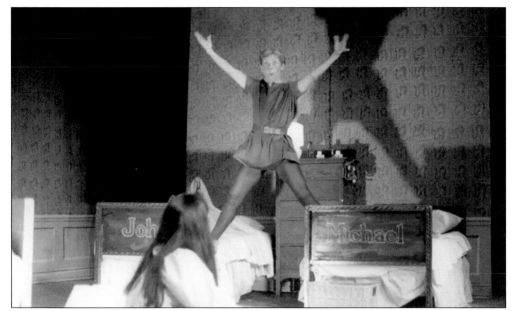

Ginger McNeese, as Peter Pan in 1984, appears at the Henry Street Playhouse, a stock company made up of town and gown. W&L students in Al Gordon and Tom Ziegler's class were given the assignment to design a stock company, and Henry Street Playhouse was the result, with productions running from 1978 through 1988. The door receipts were divided among the cast and crew. The productions were extremely professional, although they were designed for the small Troubadour stage. (Courtesy of Al Gordon.)

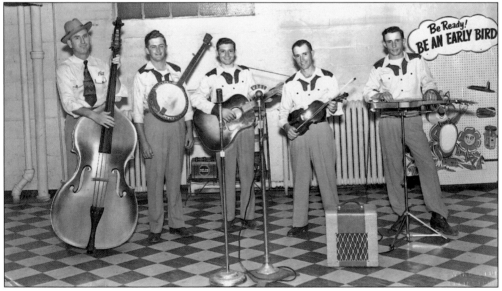

The Woody Chevrolet dealership on Main Street in the 1950s was the place for action on Saturday evenings, where the Lonesome Valley Boys sang for a radio show on WREL. The group consisted of Pat Ruley on bass, Melvin Fix on banjo, Kenny Conner on guitar, Buck Conner on violin, and Sam Conner on guitar. The crowds grew larger and larger, until there were 1,000 people attending. The event resulted in a talent show called "Your Talented Neighbor Show." (Courtesy of Taylor Woody.)

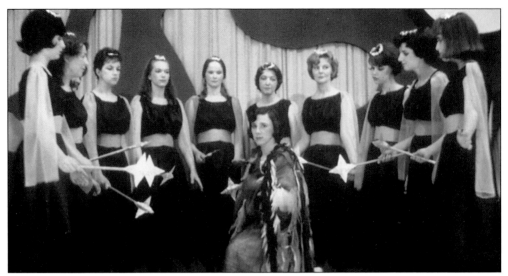

The Friends and Relatives of Gilbert and Sullivan (FROGS) presented five operettas in the 1960s and 1970s. They were *H.M.S. Pinnafore*, *Iolanthe*, *Pirates of Penzance*, *The Mikado*, and *Patience*. The *Iolanthe* women's chorus consisted of (center, kneeling) Nanalou Sauder; (standing from left to right) unidentified, Ann Heiner, Sandra Fix, Jane Rushing, Pree Ray, unidentified, Marian Carlsson, unidentified, Alice Williams, and unidentified. FROGS productions were sponsored by the Kiwanis Club. (Courtesy of Marian Carlsson.)

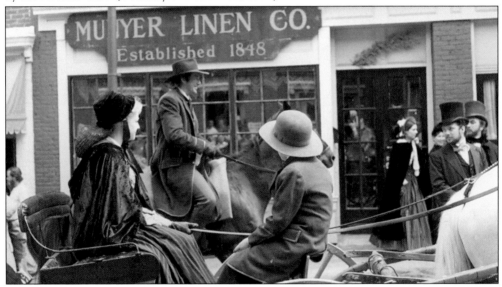

Several movies have been filmed in the Lexington area, such as *Brother Rat* featuring Ronald Reagan, *War of the Worlds* with Tom Cruise, *The Foreign Student*, *Gods and Generals* starring Robert Duvall, *Mardi Gras*, and *Sommersby*. Here Jodie Foster and Richard Gere appear on Lexington's Washington Street during the filming of *Sommersby*. Lexington has several characteristics that allow for movie-making opportunities. Parts of the campuses of Washington and Lee University and the Virginia Military Institute look essentially the same as in the 1800s. Since much of the architecture in the downtown area has preserved its 19th-century exteriors and the utility wires are underground on Main Street, by simply spreading dirt on the streets, Hollywood may create a Civil War town. (Courtesy of Alvin Carter.)

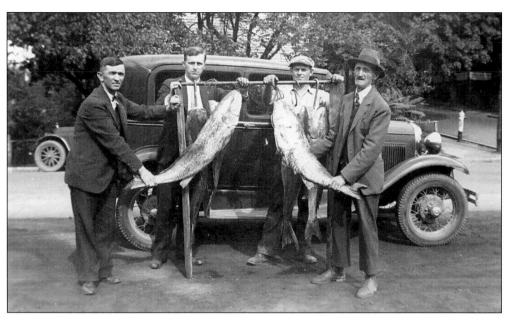

This posed picture was too good to pass up after their fishing trip. William L. Hess (second from left) wore a suit when he went fishing; M. J. Hess stands at far right. (Courtesy of Skip Hess.)

The last passenger train left the Lexington train station on June 30, 1954, and Skip Hess purchased a ticket for Balcony Falls that day. He and the ticket master are photographed as Skip holds the last ticket sold at the train station; thus ended over 80 years of passenger train service at Lexington. (Courtesy of Skip Hess.)

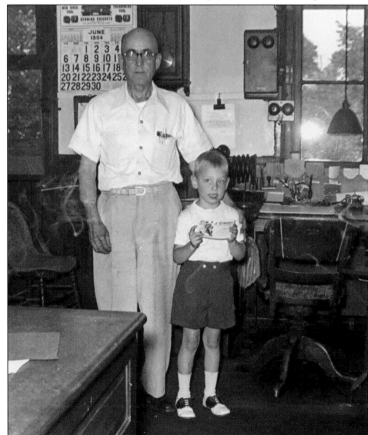

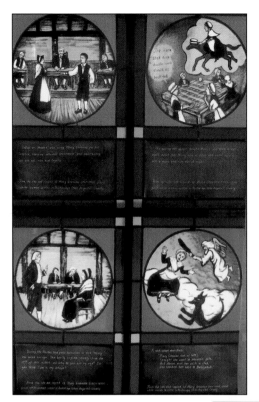

Mary Greenlee was the first white woman settler in Rockbridge County. She and her husband, James, took a tract in the Borden Grant. She was an astute businesswoman and operated a tavern. The stained glass window at the Rockbridge Historical Society depicts her as a self-assured and assertive person. According to a poem about her, after she died at age 102, "Mary Greenlee died of late. Straight she went to heaven's gate. Peter met her with a club. And knocked her back to Beelzebub." (Courtesy of the Rockbridge Historical Society/Raynal Studios.)

Margaret "Maggie" Junkin Preston, the older daughter of Washington College president George Junkin, was known as the "Poetess of the South." With her income from the sales of her poetry, she built the Beechenbrook Chapel at Jordan's Point. She was a close friend of Thomas J. Jackson, who was married to her sister Ellie. Maggie and her husband, J. T. L. Preston, assisted Jackson with the Sabbath school for slave children. (Courtesy of Special Collections, Leyburn Library, Washington and Lee University.)

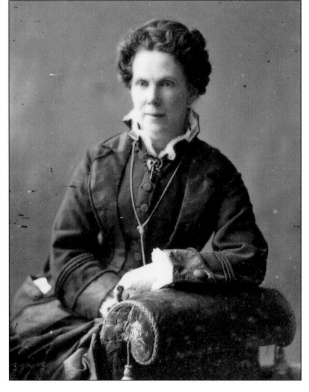

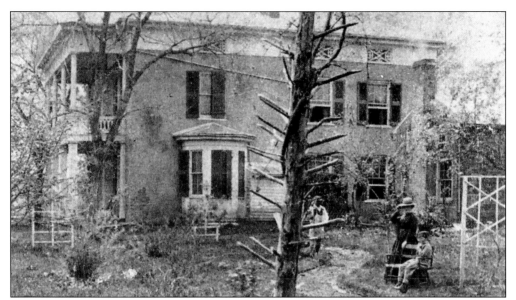

J. T. L. Preston's home was at the south end of Lee Avenue. He was a graduate of Washington College and a lawyer. As a member of the Franklin Society, he urged the need to develop the Lexington Arsenal into a military school. When the Virginia Military Institute was organized, he taught rhetoric and languages and became a member of the board of visitors. (Courtesy of Rockbridge Historical Society Collection; Special Collections, Leyburn Library, Washington and Lee University.)

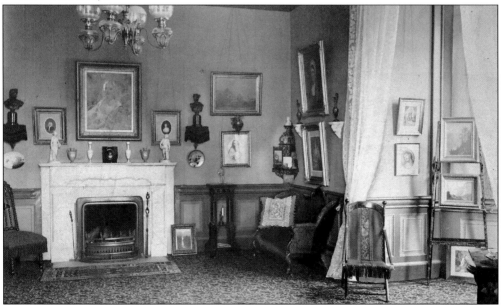

This is the parlor of the Preston home. When Gen. David Hunter raided Lexington, Margaret Junkin Preston was in this house and later wrote about the looting and destruction. The house sat on about 10 acres of land and was considered to be at the town limits. The residence has been restored and is pointed out to those visitors who take a carriage tour of Lexington. (Courtesy of Rockbridge Historical Society Collection; Special Collections, Leyburn Library, Washington and Lee University.)

Michael Miley was born in 1841 in Rockingham County, and while a boy, his family moved to Rockbridge County. In 1861, he enlisted in the Confederate infantry and served with the Stonewall Brigade under General Jackson. After the war, he learned to print pictures from wet-plate negatives, and in 1866, he formed a partnership with John C. Boude, who was his financial backer. Miley's studio, the Stonewall Gallery, was on the corner of Main and Nelson Streets, upstairs in the Hopkins building. (Courtesy of Special Collections, Leyburn Library, Washington and Lee University.)

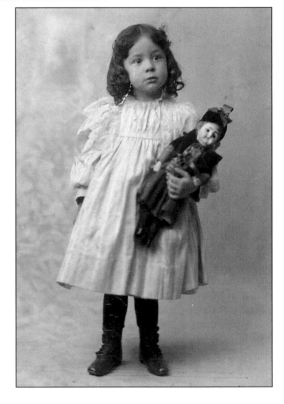

Beatrice Miley with her doll is representative of the studio shots by which Miley made his reputation. Robert E. Lee was a friend of Miley, and Lee brought his guests to be photographed at Miley's studio. Among those portraits are Jefferson Davis and Generals Jubal Early and John Breckinridge. Rockbridge County residents visited Miley's studio to have their likenesses recorded in this new form; thus a valuable archive of Lexington citizens exists. (Courtesy of Rockbridge Historical Society Collection; Special Collections, Leyburn Library, Washington and Lee University.)

After Michael Miley established himself as a photographer, around 1874 he purchased the residence at 108 White Street from Dr. James W. McClung, a physician in Lexington. Gardening was a special interest of Miley, and his greenhouse supplied flowers for his home all year long. This photograph of his house with son Henry standing on the porch testifies to Miley's fondness for gardening. (Courtesy of Michael Miley Photograph Collection; Virginia Historical Society, Richmond, Virginia; Special Collections, Leyburn Library, Washington and Lee University.)

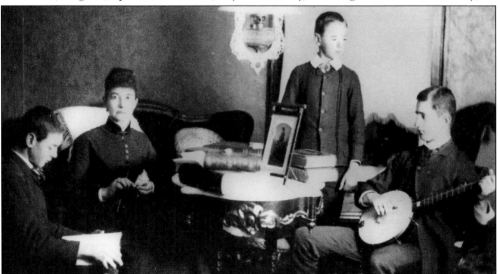

Michael Miley married Martha Mackey from Rockbridge County. This photograph shows Martha Miley and their three sons at home in the parlor. Henry, their second son, graduated from Washington and Lee University in 1894 and joined his father in the Miley studio. Contracts with W&L University and Virginia Military Institute to photograph students for their annuals provided a major source of revenue for M. Miley and Son studio. (Courtesy of Michael Miley Photograph Collection; Virginia Historical Society, Richmond, Virginia; Special Collections, Leyburn Library, Washington and Lee University.)

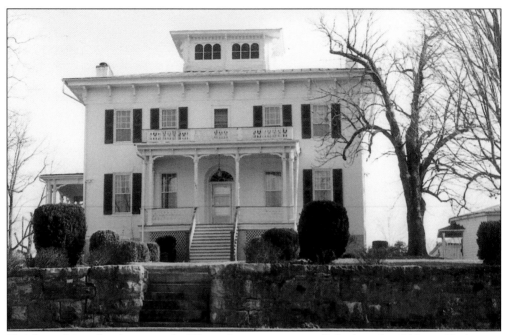

Blandome, located at the east end of Henry Street, was originally built in the 1820s, and Italianate additions were made in the 1850s. It was the Jacob Fuller home before the Civil War, and after the war, John Randolph Tucker owned the house. Harry Lee Walker bought Blandome in 1917. The Wood family currently owns it, and it is the centerpiece of the area known as Diamond Hill. (Courtesy of Rockbridge Historical Society Collection; Special Collections, Leyburn Library, Washington and Lee University.)

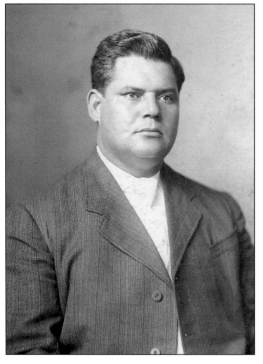

Harry Lee Walker received his name by being born on the day that the Harry Lee crew at the Washington and Lee University boat races beat the Albert Sidney crew. The Walkers were a prominent African American family whose farm furnished fresh meat to the Virginia Military Institute. He awakened at 5:00 a.m. and worked his garden and then went to his store on Main Street from 8:00 a.m. to 8:00 p.m. (Courtesy of Rockbridge Historical Society Collection; Special Collections, Leyburn Library, Washington and Lee University.)

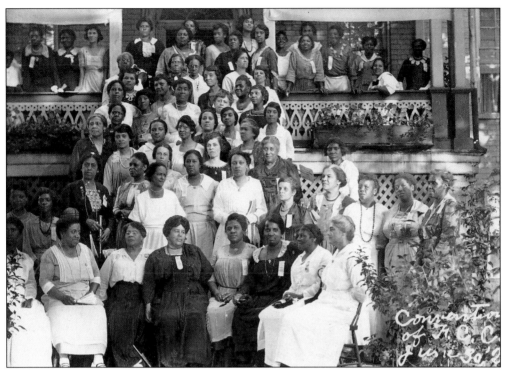

In 1921, the 14th Annual Session of the Virginia Federation of Colored Women's Clubs convened in Lexington at Blandome. This was the residence of Mrs. Eliza Walker, the leader of the Lexington organization. The local group also hosted a visit by Oscar DePriest, African American congressman from Chicago, at the First Baptist Church. (Courtesy of Wood Collection; Special Collections, Leyburn Library, Washington and Lee University.)

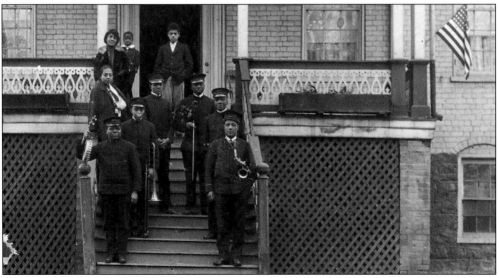

"All dressed up to go and play at a dance at W&L," says the note on this photograph. The group standing on the steps of Blandome includes Eliza Walker, Bannister Dock, Edwin T. Walker, and Nannie E. Wood. (Courtesy of Wood Collection; Special Collections, Leyburn Library, Washington and Lee University.)

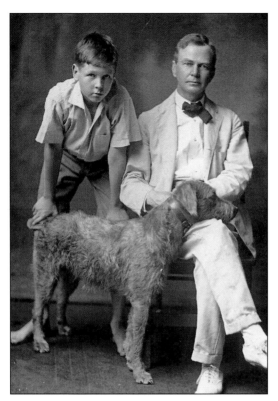

Greenlee Letcher, son of Gov. John Letcher, is shown seated in this Miley photograph with his son John Seymour "Buzz" and their dog Scout. The Letcher family has held an important place in the community for generations. Greenlee Letcher was a lawyer, active in the fire department, and a leader in Lexington. John became a World War II marine general and retired to Lexington, and his daughter, Katie Letcher Lyle, is an author living in Lexington. (Courtesy of Katie Letcher Lyle.)

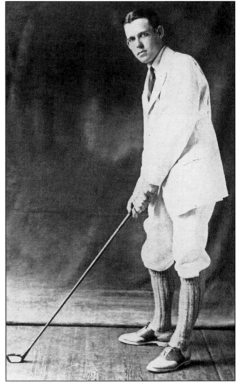

Matthew Paxton was the state golf champion in 1915 and 1916. His father was the editor of the *Rockbridge County News*. The paper business has been in the family ever since, with Matthew's son and grandson both taking up the position of publisher of the *News-Gazette*. (Courtesy of Rockbridge Historical Society Collection; Special Collections, Leyburn Library, Washington and Lee University.)

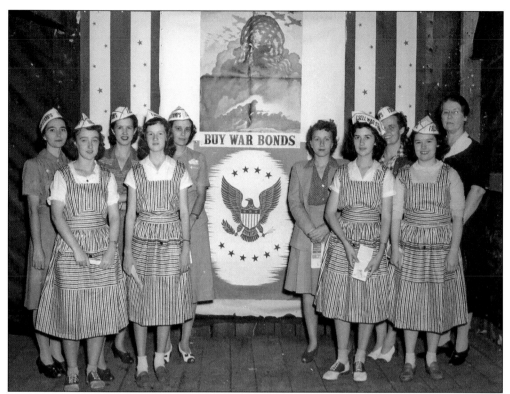

Candy stripers and women of the community championed the World War II effort as they pose in 1943 in front of this "Buy War Bonds" poster and wear hats to "Sell War Stamps." Standing from left to right are (first row) Lucy Baker, Phyllis Agnor, Virginia Lackey, and Alice Agnor; (second row) Mrs. Allen Moger, Lucille Joyce, Evelyn Thompson Law, Mrs. D. Allen Penick, Mildred "Billie" Alphin, and Mrs. Cleveland Davis. (Courtesy of Rockbridge Historical Society Collection; Special Collections, Leyburn Library, Washington and Lee University.)

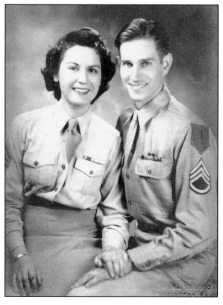

Newlyweds Sgt. Doris Coffey Hafle and S.Sgt. Donald R. Hafle had their picture taken in Lexington in July 1945. Doris, born in Lexington, enlisted in the Women's Army Corps in 1943 and served at March Field in California during World War II. Donald came to Lexington in 1933 from Ohio to work as assistant manager at J. J. Newberry, and he enlisted in the U.S. Army in 1938. He served with the 1st Division in the Signal Corps as a radio operator and served 33 months of the war in the European theater. (Courtesy of George C. Marshall Library.)

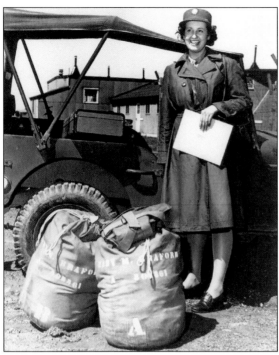

Mary Braford served in the Women's Army Corps during World War II, including assignment in Africa. Five of her brothers served in the armed forces during the war: two in the navy, two in the army in the European theater, and one in the army in the Pacific. They all came home. (Courtesy of Rockbridge Historical Society Collection; Special Collections, Leyburn Library, Washington and Lee University.)

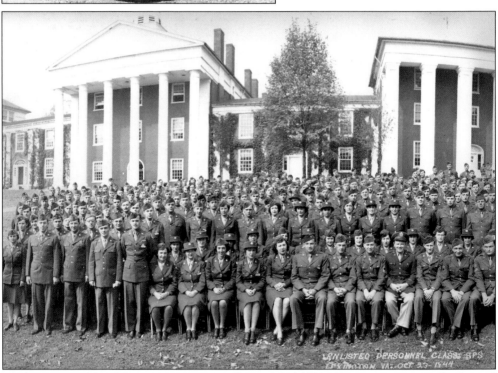

Washington and Lee University was active during World War II as a training site for Special Services personnel. Enlisted personnel pose for a group photograph in front of Washington Hall and the colonnade on October 23, 1944. (Courtesy of Special Collections, Leyburn Library, Washington and Lee University.)

Three

WASHINGTON AND LEE UNIVERSITY

In the shadows of white columns . . .

—Washington and Lee University Hymn

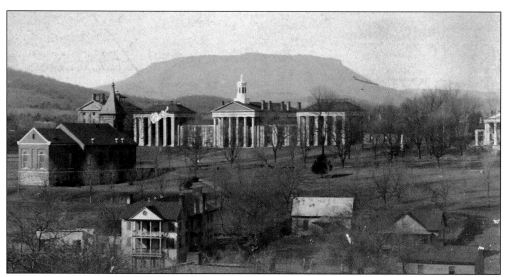

This 1894 photograph of the Washington and Lee University campus features the Blue Hotel in the foreground, Lee Chapel at the left facing Washington Hall and the colonnade, and House Mountain in the distance. The university lies in the Valley of Virginia between the Blue Ridge Mountains to the east and the Allegheny Mountains to the west. (Courtesy of Special Collections, Leyburn Library, Washington and Lee University.)

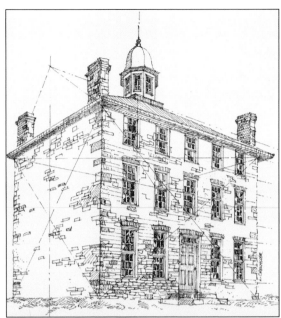

The school that is now called Washington and Lee University came about through a series of moves and name changes. In 1749, Robert Alexander was educating young men in the classics in the town of Greenville north of Lexington. This developed into Augusta Academy in 1774, then into Liberty Hall in 1776. In 1782, the school moved to Lexington as Liberty Hall Academy, just west of town. The drawing is by Larry Dreschler and is from *The Architecture of Historic Lexington* by Royster Lyle and Pamela Simpson. (Courtesy of Historic Lexington Foundation.)

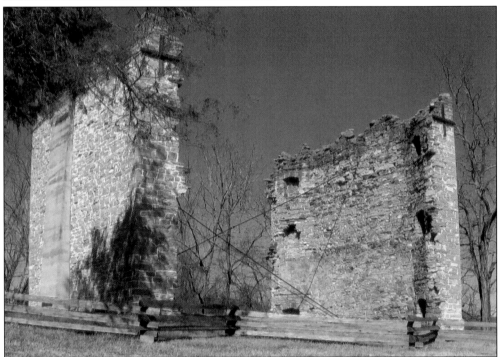

In 1782, twelve men graduated with Bachelor of Arts degrees from Liberty Hall Academy. In 1796, George Washington donated $50,000 (one hundred shares of James River Canal stock) to the school and the name was changed to Washington Academy. In 1803, fire gutted Liberty Hall and the school moved to its present location. In 1813, the General Assembly of Virginia changed the name to Washington College. In 1865, Robert E. Lee became the president and served until his death in 1870; eventually the name was changed to Washington and Lee University. The current ruins of Liberty Hall are seen above. (Courtesy of A. T. Williams.)

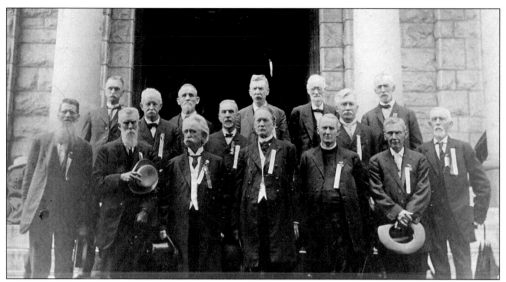

The Liberty Hall Volunteers were first organized in 1781 when students from Liberty Hall Academy took part in the Battle of Guilford Courthouse in North Carolina during the Revolutionary War. The Liberty Hall Volunteers (Company 1, 4th Virginia) reorganized during the Civil War. Under Gen. Thomas J. Jackson, they fought in the Stonewall Brigade of the Army of the Shenandoah and in the 2nd Corps of the Army of Northern Virginia. They were men from all levels of society, many from Rockbridge County, and are shown here during a reunion in 1910. (Courtesy of Rockbridge Historical Society Collection; Special Collections, Leyburn Library, Washington and Lee University.)

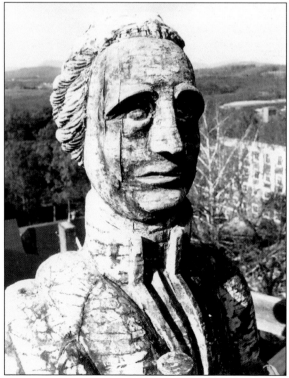

A statue of George Washington "Old George," carved by local cabinetmaker Matthew Kahle in 1844 from a log floating in the Maury River, stood atop Washington Hall. In 1990, the wooden figure was in need of repair and a new bronze statue, painted white, replaced the old one. (Courtesy of Special Collections, Leyburn Library, Washington and Lee University.)

In 1865, Robert E. Lee was invited by the trustees of Washington College to become their school's president. In the five years that he held this position, he added a journalism department, a law school, and a business school. He also inspired an honor system that is one of the hallmarks of Washington and Lee University today. (Courtesy of Special Collections, Leyburn Library, Washington and Lee University.)

Lee House was built as the president's residence for Robert E. Lee in 1868. Designed by C. W. Oltmanns, a member of the engineering department at VMI, it featured wide porches for Mary Anna Lee's wheelchair (she was arthritic). A spacious side building housed Traveller, Lee's horse. (Courtesy of Michael Miley Photograph Collection; Virginia Historical Society, Richmond, Virginia; Special Collections, Leyburn Library, Washington and Lee University.)

Robert E. Lee's wife was Mary Anna Randolph Custis, the great-granddaughter of Martha Washington. Often she was asked for a snippet of General Lee's hair, and she complied with these requests until Lee began looking shaggy. Mary Anna Lee painted scenes, and for the local Episcopal church fund-raisers, she colorized prints of George Washington's portrait. The church was ultimately named the R. E. Lee Memorial Episcopal Church. (Courtesy of Michael Miley Photograph Collection; Virginia Historical Society, Richmond, Virginia; Special Collections, Leyburn Library, Washington and Lee University.)

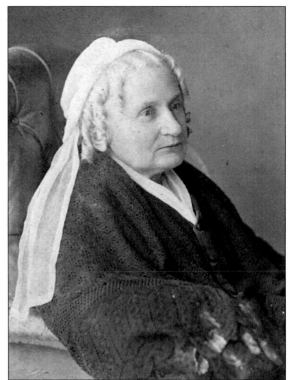

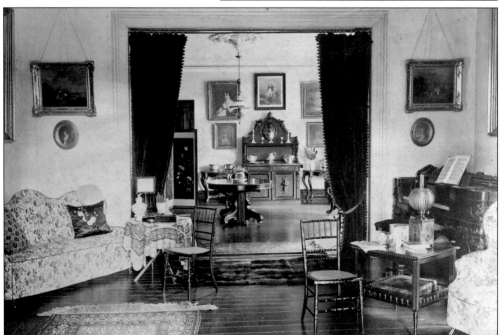

This photograph of the parlor and dining room of Lee House was taken while occupied by George Washington Custis Lee, but it shows the rooms essentially as occupied by Robert E. Lee while president. The house is still used as the residence for the president of Washington and Lee University. (Courtesy of Special Collections, Leyburn Library, Washington and Lee University.)

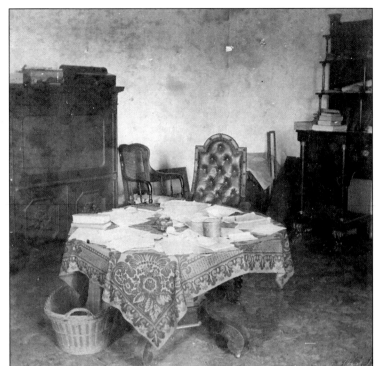

Robert E. Lee's office, in the lower level of Lee Chapel, is just as he left it on his last day of work in 1870, as photographed by Michael Miley. A visitor to the museum may also see the Lee family crypt where General Lee, his wife, seven children, and father, "Light Horse" Harry Lee, are buried. Outside the lower entrance to Lee Chapel, Lee's horse, Traveller, is buried. (Courtesy of Special Collections, Leyburn Library, Washington and Lee University.)

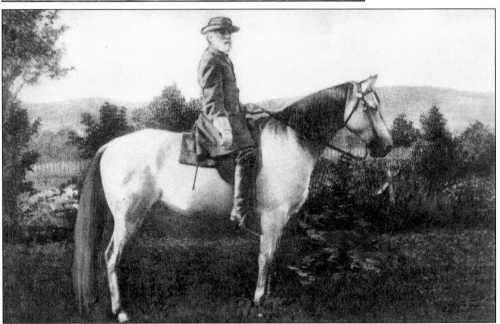

General Lee rode Traveller to Lexington when he became the president of Washington College. Lee liked the community of Lexington and would ride east to a hilltop now called Lee's View. The famous Miley photograph of Lee on Traveller was made at Lee's request. General Lee put on his Confederate uniform, and it was the only time he had his image made by Miley in the uniform. The photograph was made in Lexington, behind Lee's house in the garden. (Courtesy of Special Collections, Leyburn Library, Washington and Lee University.)

Robert E. Lee died on October 12, 1870. His funeral procession began in downtown Lexington on the corner of Main and Nelson Streets and proceeded to Lee Chapel, where a huge crowd had gathered. (Courtesy of Special Collections, Leyburn Library, Washington and Lee University.)

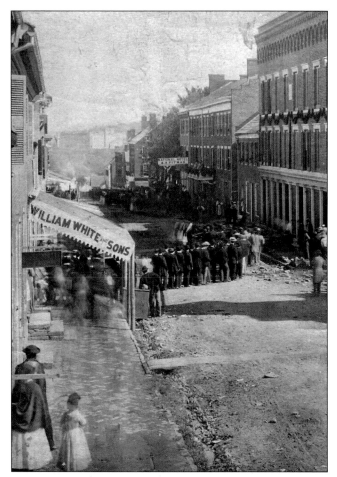

After his death, Robert E. Lee's body lay in state in Lee Chapel. Students from the college and cadets from the Virginia Military Institute kept watch. This photograph shows the chapel draped in mourning. (Courtesy of Special Collections, Leyburn Library, Washington and Lee University.)

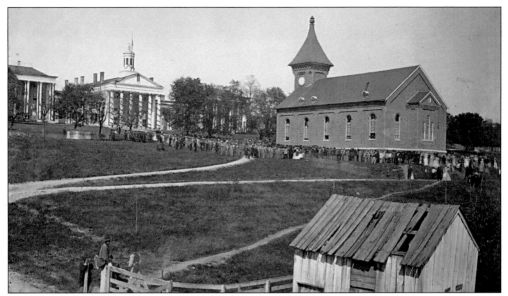

Washington College was draped in black for Robert E. Lee's funeral. This sweeping landscape is by photographer Michael Miley. (Courtesy of Michael Miley Photograph Collection; Virginia Historical Society, Richmond, Virginia; Special Collections, Leyburn Library, Washington and Lee University.)

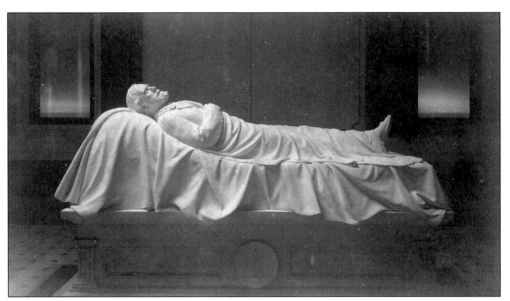

Edward Valentine was the sculptor of the Robert E. Lee recumbent statue in Lee Chapel. Valentine studied anatomy at the University of Virginia, and he had made exact measurements of Lee before his illness. The white marble statue (completed in 1875) is lifelike, depicting the general asleep on his camp bed. (Courtesy of Special Collections, Leyburn Library, Washington and Lee University.)

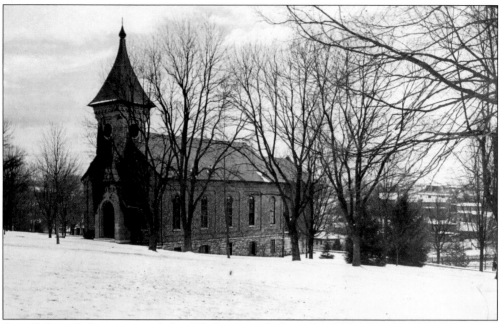

Pres. Robert E. Lee suggested that Washington College should have a chapel; construction began in 1867 and was completed for graduation in 1868. The plans were prepared by VMI professor Thomas H. Williamson. In 1962, the Ford Motor Company Fund gave $370,000 for the restoration of Lee Chapel. (Courtesy of Special Collections, Leyburn Library, Washington and Lee University.)

George Washington Custis Lee succeeded his father as the president of Washington and Lee University, serving from 1871 to 1897. He was a West Point graduate, and after the Civil War, he taught at the Virginia Military Institute. (Courtesy of Special Collections, Leyburn Library, Washington and Lee University.)

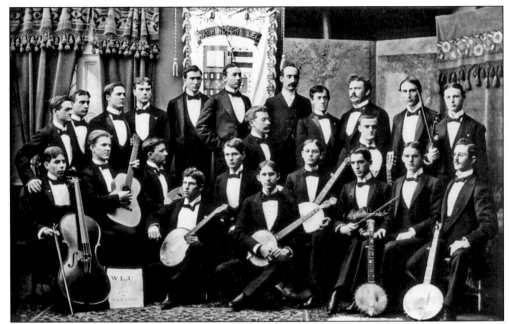

The banjo was a favorite musical instrument of this W&L band in 1892. Student John W. Davis (back row, fourth from the right) went on to become the Democratic presidential candidate in 1924. (Courtesy of Special Collections, Leyburn Library, Washington and Lee University.)

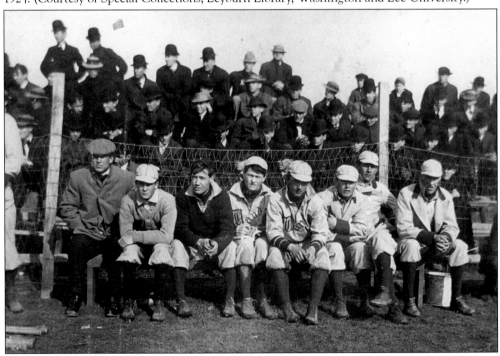

From the C. P. Robinson album of 1906–1910 comes this picture of the Washington and Lee University baseball subs on the players' bench. The hats of the spectators vary from the black bowler hats to the pull-down cap. Incidentally, the score was Davidson 2, W&L 1. (Courtesy of Special Collections, Leyburn Library, Washington and Lee University.)

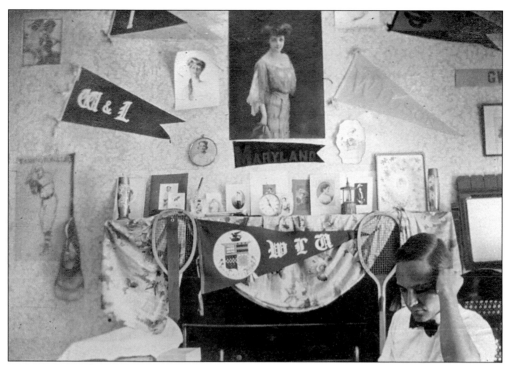

A *c.* 1906 Washington and Lee University student's room can be seen in C. P. Robinson's album. The room is similar to that of a VMI cadet's room (page 108) of this period, with Victorian decor replete with pictures. (Courtesy of Special Collections, Leyburn Library, Washington and Lee University.)

Robert C. Hood, a student at W&L from 1908 to 1912, lived in the Delta Tau Delta fraternity house shown in this picture from his personal album. The description in his yearbook says, "Bob wears a perennial smile and attends prayer meeting regularly." He was the senior class president. His fraternity brothers, on the roof, don't appear to be nearly as responsible as Hood. (Courtesy of Special Collections, Leyburn Library, Washington and Lee University.)

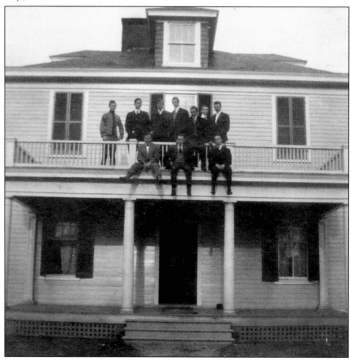

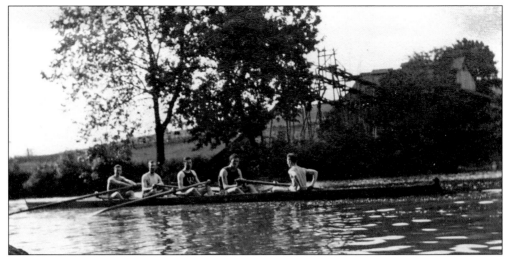

In 1874, boating competition began at Washington and Lee University. The Albert Sidney and the Harry Lee crews raced to a draw that year. From 1875 to 1896, the Albert Sidney won 10 races and the Harry Lee won 9. There were two draws. Shown above is the 1910 winning crew in the Albert Sidney shell. (Courtesy of Special Collections, Leyburn Library, Washington and Lee University.)

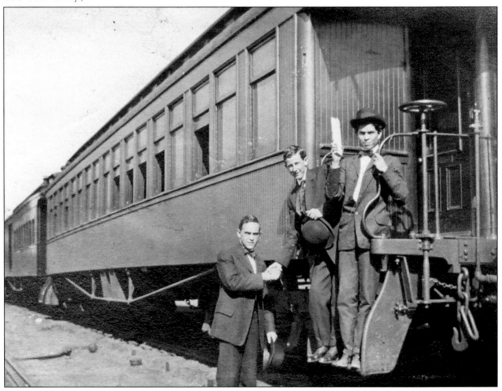

This train is leaving Lexington in the late spring of 1910. In C. P. Robinson's album, this picture has the note, "Said my last farewell Toot-toot goodbye." In the years before the widespread use of automobiles, many students and cadets arrived in and departed from Lexington by train. (Courtesy of Special Collections, Leyburn Library, Washington and Lee University.)

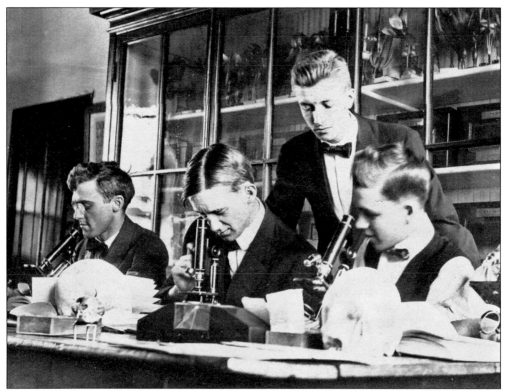

Washington and Lee University has always had a strong science program. This *c.* 1910 photograph shows students working in a biology laboratory. Notice the coats and ties and the human skulls on the table. (Courtesy of Special Collections, Leyburn Library, Washington and Lee University.)

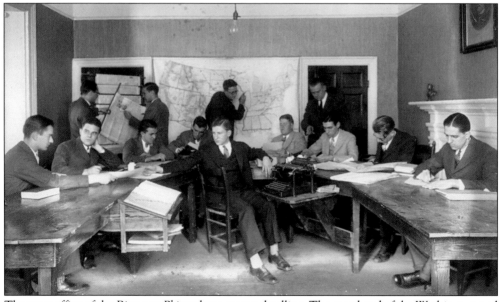

The news office of the *Ring-tum Phi* works to meet a deadline. The masthead of the Washington and Lee University newspaper states that it has been published "by the students and for the students since 1897." (Courtesy of Special Collections, Leyburn Library, Washington and Lee University.)

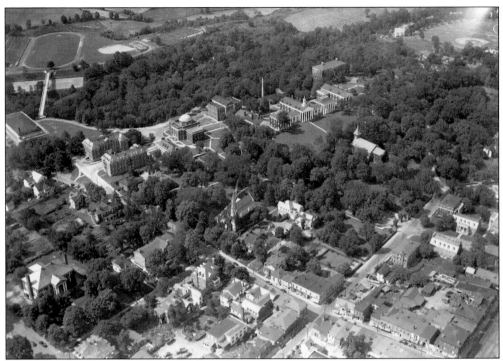

An aerial view of the Washington and Lee University campus around 1938 shows the dome of the Carnegie Library. There are two church spires: center right is Lee Chapel, and the one in the middle of the photograph is R. E. Lee Memorial Episcopal Church and is just off of the campus. The colonnade is visible, and the footbridge to the track and football field is at the top left. (Courtesy of Special Collections, Leyburn Library, Washington and Lee University.)

The Washington and Lee University Carnegie Library was financed by a $50,000 gift from Andrew Carnegie. In the upper level, there was an art gallery. The dome of the library was removed in 1940 and the library enlarged to become McCormick Library. (Courtesy of Special Collections, Leyburn Library, Washington and Lee University.)

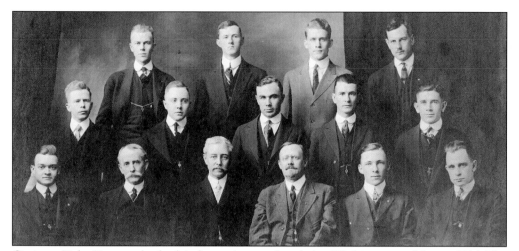

Omicron Delta Kappa, a leadership fraternity, was founded at Washington and Lee in 1914. The founding members are, from left to right, (first row) J. Carl Fisher, David C. Humphreys, Henry L. Smith, D. Benjamin Easter, William M. Brown, and Carl S. Davidson; (second row) Philip P. Gibson, John P. Richardson, Edward P. Davis, William C. Raftery, and Edward A. Donahue; (third row) John E. Martin, James E. Bear, Rupert N. Latture, and Thomas M. Glasgow. (Courtesy of Special Collections, Leyburn Library, Washington and Lee University.)

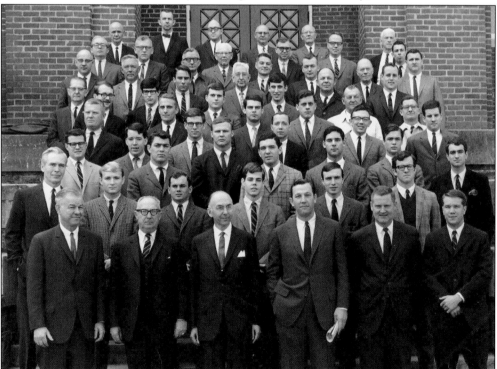

The purpose of Omicron Delta Kappa is to recognize and encourage achievement in scholarship, athletics, community service, social and religious activities, government, journalism, and the arts. Among the members included in this 1966 photograph are (first row) Pres. Fred Cole (first), journalist Roger Mudd (fourth), and future governor Linwood Holton (fifth). (Courtesy of Special Collections, Leyburn Library, Washington and Lee University.)

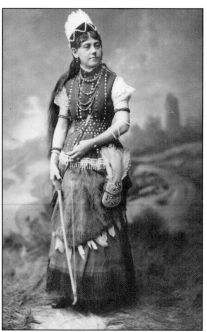

In 1876, Annie Jo White organized a dance called the Fancy Dress Hop at Washington and Lee. The Bal Masque was a costume party, and she appeared as Pocahontas. White organized the first Fancy Dress Ball in 1907, and the tradition continued. Each year, a theme was chosen and a rental company furnished the costumes; Annie Jo White attended more than 30 of these dances. (Courtesy of Michael Miley Photograph Collection; Virginia Historical Society, Richmond, Virginia; Special Collections, Leyburn Library, Washington and Lee University.)

Annie Jo White was the librarian at W&L, and in her yearly reports to the president, she emphasized the place of the library in the curriculum. She was also a faithful supporter of student activities. When Fancy Dress started, she used money from the theater productions to rent costumes. When the rowing team needed a shell (racing boat), the crew went to White for the funds. (Courtesy of Special Collections, Leyburn Library, Washington and Lee University.)

The early Fancy Dress Balls began with a formal figure. Here around 1918, Matthew Paxton and Yutha Young, as George and Martha Washington, were introduced, and the other couples followed. As the years progressed, King Arthur's Court became a popular theme. Later years focused on the bands that provided the music. Notable band leaders included Eddie Duchin, Count Basie, Kay Kyser, Glenn Miller, Harry James, Benny Goodman, and Louis Armstrong. (Courtesy of Matthew Paxton.)

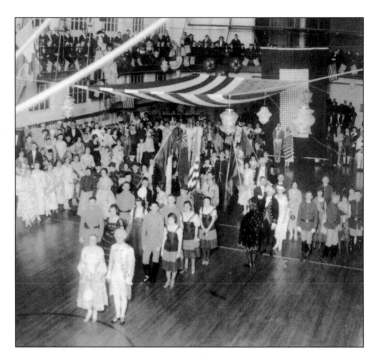

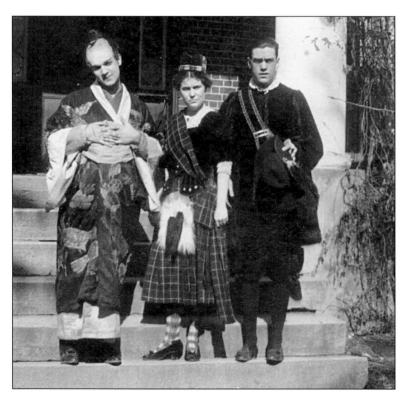

Obtaining the costumes for Fancy Dress was no easy matter. When the costumes arrived, sometimes on the day of the dance, there were adjustments to be made. In this 1911 photograph, John Graham (left) is seen in an elaborate Japanese outfit. The couple to the right is in Scottish attire. (Courtesy of Special Collections, Leyburn Library, Washington and Lee University.)

83

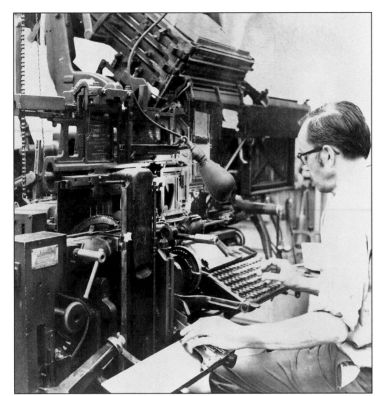

One of the most important jobs at Washington and Lee University was the work done by the print shop. The Fancy Dress graphics reflected the era chosen for the costumes and decor. The elaborate programs were kept as souvenirs. This Linotype machine, operated by Hunter McCoy, was a work of art in itself. (Courtesy of Special Collections, Leyburn Library, Washington and Lee University.)

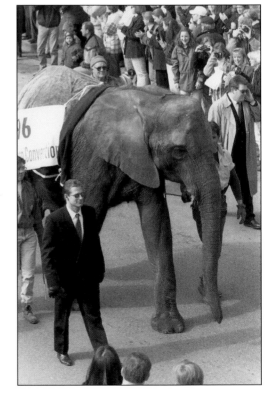

Every four years, Washington and Lee University students hold a mock political convention in the spring before the November election. Students are organized into state delegations, as at the actual national convention, and there is a parade through downtown Lexington. In 1996, an elephant was included in the parade. (Courtesy of Special Collections, Leyburn Library, Washington and Lee University.)

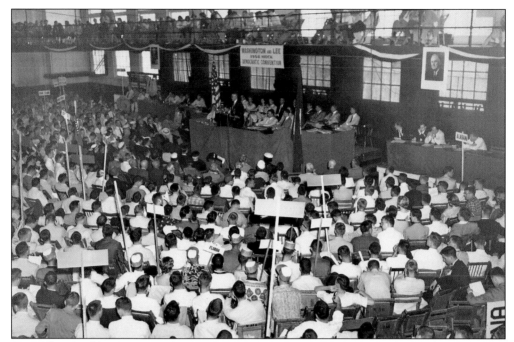

Sen. Alben Barkley, vice president in the Truman administration, spoke during the 1956 Mock Convention. "I would rather be a servant in the house of the Lord, than to sit in the seats of the mighty," said Barkley on April 30, 1956. At that moment, he collapsed and died of a heart attack. (Courtesy of Special Collections, Leyburn Library, Washington and Lee University.)

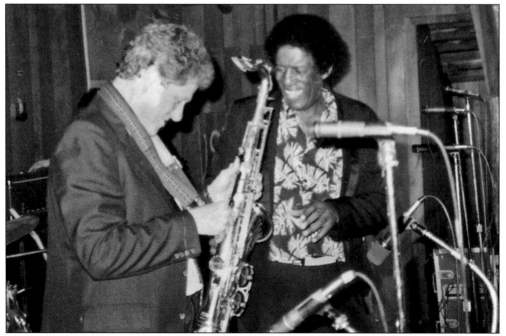

The Mock Convention sometimes provides candidates a chance to hone their political skills. In 1988, Bill Clinton took up his saxophone at an after-session fest at Zollman's Pavilion. (Courtesy of Special Collections, Leyburn Library, Washington and Lee University.)

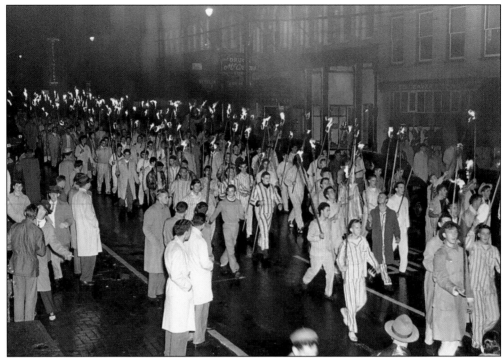

Washington and Lee University students were called Minks. In the 1950s, a freshman had to wear a beanie, a small skullcap displaying the blue and white colors. For the homecoming parade, the freshmen carried torches down Main Street and wore striped pajamas. (Courtesy of Special Collections, Leyburn Library, Washington and Lee University.)

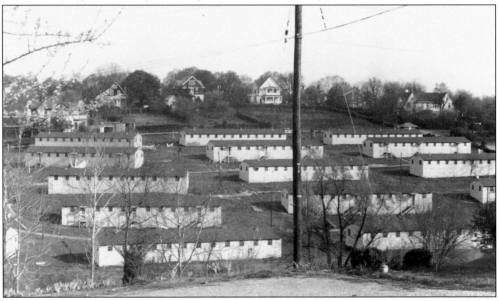

After World War II, many students went to college on the GI Bill. In order to house these men, many of them married, low-budget buildings were constructed, such as these buildings near Waddell School. The last of these housing units, at Davidson Park on Nelson Street, were razed in 1982. (Courtesy of Special Collections, Leyburn Library, Washington and Lee University.)

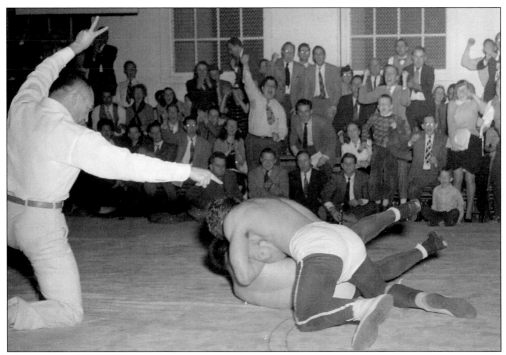

The action of the referee and the reaction of the crowd indicate that this is an important two points; W&L wins the 1948 final wrestling competition for the Southern Conference championship. At one period during the reign of this sport, Washington and Lee won three of four Southern Conference titles, and the one they lost went to VMI. (Courtesy of Special Collections, Leyburn Library, Washington and Lee University.)

This is the 1989 Lee-Jackson Lacrosse Classic played between Washington and Lee University and the Virginia Military Institute. These Lexington neighbors met on the sports field in the first half of the 20th century; however, the rivalry became too intense, and it was decided not to encourage the negative feelings. They now compete again with gentlemanly athleticism. (Courtesy of Special Collections, Leyburn Library, Washington and Lee University.)

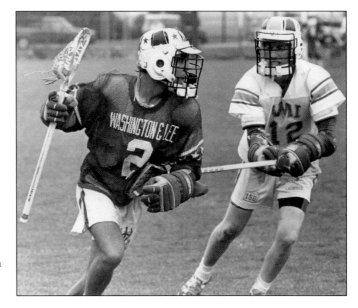

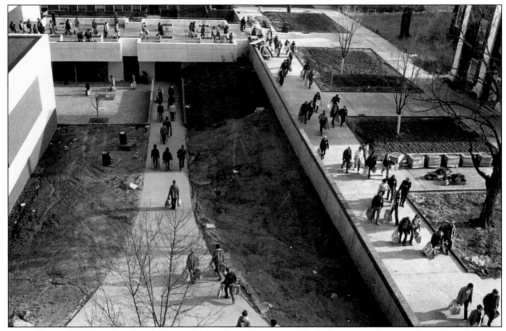

How do you move a library from one building to another? The great move of 1979 into the new Leyburn Library is underway. Students stationed at the old McCormick Library filled paper bags with books; then volunteers carried the bags to the new library, where the books were shelved at their new locations. The townspeople were invited to help accomplish this monumental task, and many did. (Courtesy of Special Collections, Leyburn Library, Washington and Lee University.)

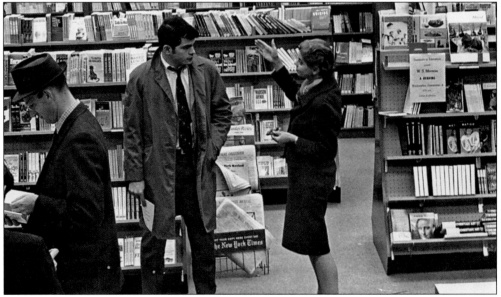

During the last half of the 20th century, the Washington and Lee University bookstore was more than a place to buy textbooks. It had expanded into two parts. One offered school supplies and memorabilia; the other offered the latest popular reading. The store also featured faculty publications and a small art gallery. Here Betty Munger helps a customer. (Courtesy of Special Collections, Leyburn Library, Washington and Lee University.)

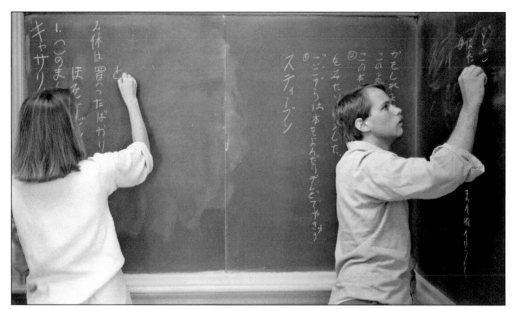

In recent years, a strong curriculum in Asian studies has developed to include art, culture, and religion. These students are practicing Chinese calligraphy. Supporting these studies, the Reeves Collection exhibits Chinese export pottery, and there is an authentic room for tea ceremonies. (Courtesy of Special Collections, Leyburn Library, Washington and Lee University.)

Washington and Lee University has many well-known alumni who return to lecture or lead seminars. Here a seminar is being conducted by Charles McDowell (left), class of 1948 and columnist for the *Richmond Times*, and Roger Mudd (right), class of 1950 and television journalist. (Courtesy of Special Collections, Leyburn Library, Washington and Lee University.)

Washington and Lee University has had a Department of Fine Arts since 1949. In 1991, W&L dedicated the Lenfest Center that features a black box theater, large auditorium, space for art exhibits, shops for scenery construction, and rehearsal rooms. Later Wilson Hall was added with classrooms, art studios, and a recital hall. (Courtesy of A. T. Williams.)

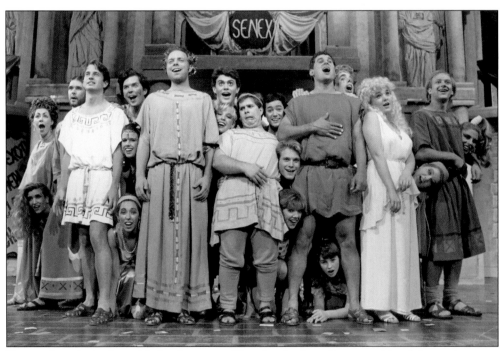

Plays and musicals abound in Lexington; public schools, the colleges, and local dramatic groups produce many shows each year. *A Funny Thing Happened on the Way to the Forum* was a W&L production at the Lenfest Center for the Arts. (Courtesy of Al Gordon.)

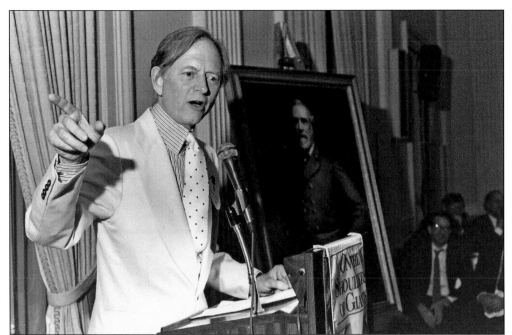

Washington and Lee University invites its rich and famous to return to the campus as board members or as speakers. Noted author Tom Wolfe, in his traditional white suit, often returned. He helped with the 1990s campaign "On the Shoulders of Giants" during which $147 million was raised for the university. (Courtesy of Special Collections, Leyburn Library, Washington and Lee University.)

Between the Washington and Lee University colonnade and Main Street, there is a lawn known as the hollow. It was a favorite sledding place for the families living on the VMI and W&L campuses. Shown in the photograph are, from left to right, Nancy Williams, Pinky Barksdale, Skip Williams, Alice Williams, and Barbara Williams. (Courtesy of A. T. Williams.)

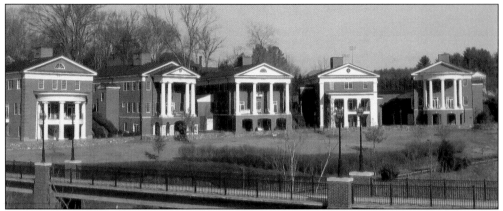

In 1985, the first women were admitted to Washington and Lee University. Many changes have taken place because of the presence of women: five sororities were organized, new houses were built for them, and the academic quality of the student body has risen. (Courtesy of A. T. Williams.)

Three college fraternities—Sigma Nu, Kappa Alpha, and Alpha Tau Omega—were founded in Lexington. After the Civil War, Otis A. Glazebrook, a New Market cadet, wanted "a fraternal organization of young men, of a rational character, entirely free of partisan or sectional bias." He helped to found Alpha Tau Omega at VMI in 1865. Sigma Nu was established by three cadets who began a movement to abolish the hazing system at VMI. They were James F. Hopkins, Greenfield Quarles, and James M. Riley. Several bronze plaques in Robinson Hall at W&L commemorate the founding of the Kappa Alpha Order in Lexington in 1865. Both Sigma Nu and Kappa Alpha have their national headquarters in Lexington. (Courtesy of A. T. Williams.)

Four

VIRGINIA MILITARY INSTITUTE

You may be whatever you resolve to be.

—Thomas J. Jackson

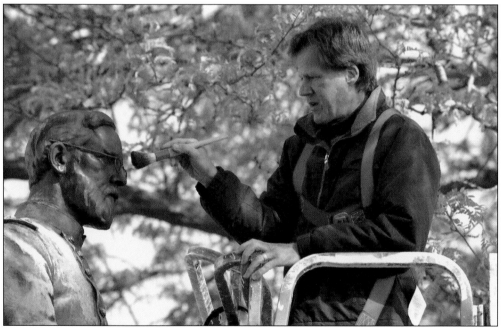

Francis Henney Smith was superintendent of the Virginia Military Institute from its first day, November 11, 1839, until 1889. A graduate of West Point and a mathematics teacher at Hampden-Sydney College, he was asked to assume the Lexington position by Claudius Crozet, first president of the VMI Board of Visitors. A Virginia arsenal occupied the site, and young men were needed to guard the facility. The state agreed to support a college that would train teachers and other professionals; Smith would develop the curriculum and the military structure. The vision of Francis Smith and others to produce "citizen-soldiers" came into being and has endured. Pictured here, Andrew Baxter attaches the glasses onto Smith's statue after cleaning it in 2008. The statue by sculptor Ferrucio Legnaioli, dedicated in June 1931, had removable spectacles since there was debate over including glasses for the longtime superintendent, nicknamed "Old Specs." (Courtesy of Communications and Marketing, Virginia Military Institute.)

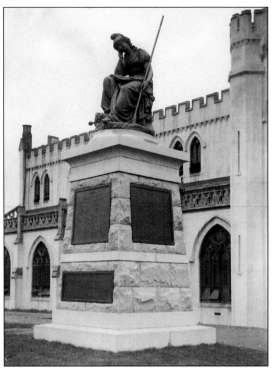

Virginia Mourning Her Dead by sculptor Moses Ezekiel (VMI, 1866) is shown at its original location in front of Jackson Arch, where it was dedicated in 1903 and remained until 1912, when it was moved to its current location in front of Nichols Engineering Building. Ezekiel was at VMI on May 11, 1864, when Gen. John C. Breckinridge called upon the institute to send cadets to serve in reserve for his troops at New Market. It took four days for the 257 cadets to march the 80 miles to the battlefield. They were called into action on May 15, 1864, under Col. Scott Shipp, and they fought bravely. Moses Ezekiel studied in Europe and produced this statue honoring the cadets who died at the Battle of New Market. (Courtesy of VMI Archives.)

Jackson Memorial Hall on the Virginia Military Institute campus is used for religious services, student meetings, and concerts and houses the VMI Museum. The mural on the front wall is *The Battle of New Market* painted by Benjamin West Clinedinst (VMI, 1880). Unveiled in 1914, the painting measures 18 by 23 feet and depicts the cadets crossing the battlefield during their charge at New Market. Ten cadets were killed: Samuel Francis Atwill, William Henry Cabell, Charles Gay Crockett, Alva Curtis Hartsfield, Luther Cary Haynes, Thomas Garland Jefferson, Henry Jenner Jones, William Hugh McDowell, Jaqueline Beverly Stanard, and Joseph Christopher Wheelwright. Each year on May 15, the VMI Corps remembers their sacrifice with a parade and a rifle salute. (Courtesy of George C. Marshall Library.)

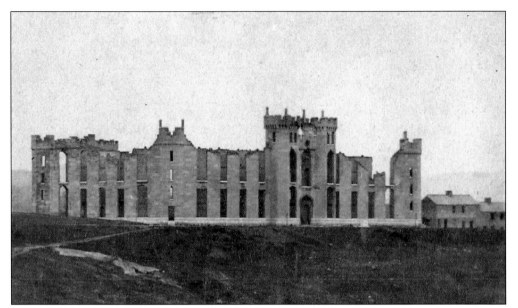

On June 11, 1864, Union forces under command of Maj. Gen. David Hunter attacked the Virginia Military Institute, considered a legitimate target since it housed an arsenal and a military training school. Union troops positioned guns on the hill across the river from VMI and proceeded to shell the barracks and several professors' quarters. The superintendent's home was spared and became the headquarters of General Hunter for the three days he occupied Lexington. (Courtesy of VMI Archives.)

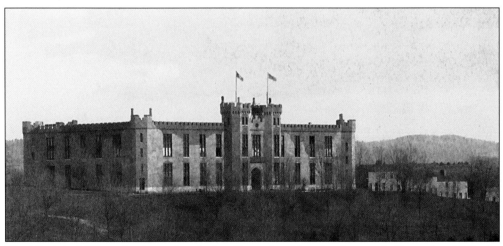

The Virginia Military Institute closed after Hunter's raid on Lexington. In December 1864, the cadets resumed their studies at the Alms House in Richmond, and the Corps stayed there until April 1865. In October 1865, the school in Lexington opened again. The repairs to the barracks are visible in this Michael Miley photograph taken around 1875. (Courtesy of VMI Archives.)

Thomas J. "Stonewall" Jackson grew up in West Virginia and received an appointment to the U.S. Military Academy in 1842. Overcoming his poor academic background, he graduated in the top third of his class and received his commission as lieutenant of artillery. He was in the Mexican War with Robert E. Lee. Jackson left the army in 1851 to join the faculty of the Virginia Military Institute. He taught natural philosophy (physics) and artillery tactics, was an elder in the Lexington Presbyterian Church, and taught a Sabbath school for the children of slaves and freedmen. He was known to sleep in church, and he was mocked by the cadets for his stern nature. He favored the preservation of the Union but followed Virginia into the Confederacy in April 1861. This image of Jackson was taken by Samuel Pettigrew in 1857 in Lexington. (Courtesy of the Stonewall Jackson House Collection, Stonewall Jackson Foundation, Lexington, Virginia.)

Thomas J. Jackson married Elinor Junkin in 1853. Her father was the president of Washington College and a minister. They were married by Pres. George Junkin in the building now known as the Lee-Jackson House on the campus, which then served as the president's house. (Courtesy of the Stonewall Jackson House Collection, Stonewall Jackson Foundation, Lexington, Virginia.)

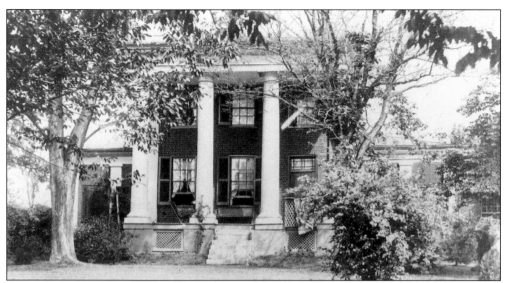

This is the Lee-Jackson House on the Washington and Lee University campus. After the wedding, Elinor "Ellie" and Thomas Jackson set up housekeeping in the northern wing of this house. Ellie gave birth to a stillborn son on October 22, 1854, and soon after, she died. Thomas consoled himself by traveling to Europe. (Courtesy of Michael Miley Photograph Collection; Virginia Historical Society, Richmond, Virginia; Special Collections, Leyburn Library, Washington and Lee University.)

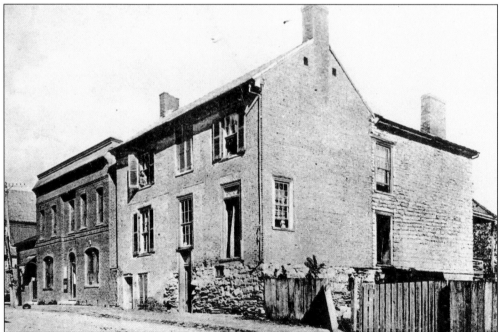

In 1858, Jackson married Mary Anna Morrison, whose father, like Ellie's, was a Presbyterian minister and president of a college (Davidson). The Jacksons lived for two years at 8 East Washington Street before he was called to service in the Confederate army. They had only one surviving child, Julia, born November 23, 1862, in Charlotte, North Carolina. (Courtesy of Rockbridge Historical Society Collection; Special Collections, Leyburn Library, Washington and Lee University.)

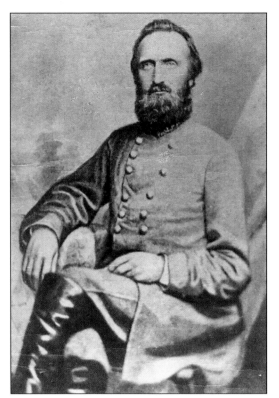

While sitting for this portrait in November 1862 at the studio of Nathaniel Routzahn in Winchester, Virginia, Stonewall Jackson was told that one of his buttons was missing. He asked for needle and thread and sewed on the button himself. The photographer then made this picture showing the button out of line. (Courtesy of Rockbridge Historical Society Collection; Special Collections, Leyburn Library, Washington and Lee University.)

Jackson fought against Gen. Joseph Hooker's Union forces at Chancellorsville. The evening after the battle, he was scouting ahead of his lines on his horse Little Sorrel, and in the darkness, his own men accidentally shot him in the left arm. His wife, Anna, and child went to visit him near the battlefield. He died on May 10, 1863; his daughter, Julia Laura Jackson, was only six months old. Here she is shown at about four with her mother. (Courtesy of the Stonewall Jackson House Collection, Stonewall Jackson Foundation, Lexington, Virginia.)

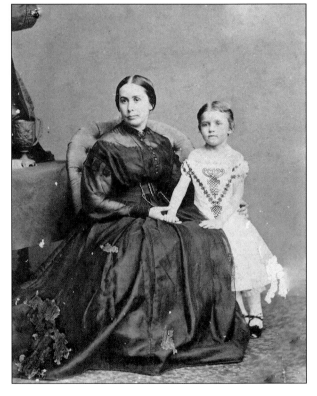

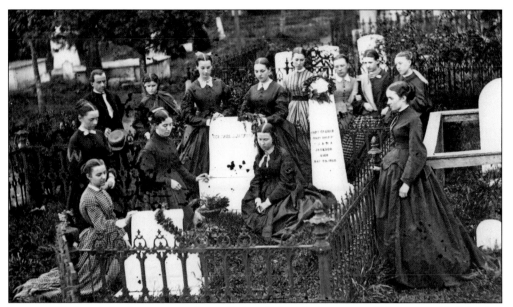

Stonewall Jackson's death was a great loss to Robert E. Lee. Jackson moved his troops with lightning speed and won against a much larger force. The Stonewall Brigade and the New Market cadets had made their mark in the Civil War, but there were many losses to Lexington. Here a group of young ladies (probably students at Ann Smith Academy) and a gentleman in the Jackson plot mourn the death of their hero. (Courtesy of Michael Miley Photograph Collection; Virginia Historical Society, Richmond, Virginia; Special Collections, Leyburn Library, Washington and Lee University.)

In 1891, a statue of Jackson was erected in the Lexington Presbyterian Church cemetery. A huge crowd assembled for the event; Jackson's four-year-old granddaughter, Julia Christian, is standing on the raised platform to the right of the statue. Today it is a popular tourist spot, and one can often see lemons on the grass beneath Jackson's feet. The lemons, left by visitors, recall Jackson's use of the fruit as a health food. (Courtesy of Michael Miley Photograph Collection; Virginia Historical Society, Richmond, Virginia; Special Collections, Leyburn Library, Washington and Lee University.)

Jackson's home eventually became Stonewall Jackson Memorial Hospital. The house was originally a simple brick structure built in 1801 for county jailer Cornelius Dorman. In 1845, owner Archibald Graham built a stone addition to the back, and in 1851, the street was lowered. Jackson bought the house in 1858, and after his death, it was rented until, in 1904, the United Daughters of the Confederacy bought the property and converted the building into a hospital. Many of the local citizens can brag that they were born in the Stonewall Jackson House. It is now restored and preserved as a museum to Jackson, and the grounds feature a vegetable and flower garden as well as a carriage house. (Courtesy of Rockbridge Historical Society Collection; Special Collections, Leyburn Library, Washington and Lee University.)

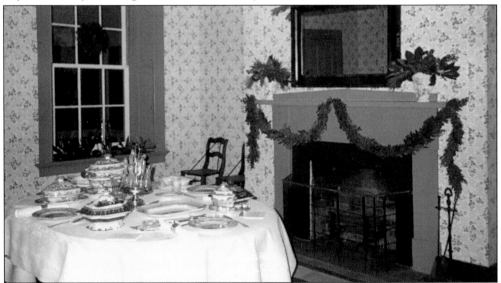

The Stonewall Jackson House operates as a nonprofit corporation. Docents describe the life and times of the Jackson family as they lead small groups on tours of the home. The rooms contain 1850s furniture and during holidays are decorated with the same types of plants, candles, and ribbons Anna Jackson would have used. (Courtesy of Rockbridge Historical Society Collection; Special Collections, Leyburn Library, Washington and Lee University.)

A large crowd gathered for the dedication of the Stonewall Jackson House on October 24, 1979. Mayor Charles F. Phillips speaks during the dedication ceremony. Other dignitaries included the president of the Historic Lexington Foundation, the chairman of the Virginia Historic Landmarks Commission, and Gov. Mills Godwin. (Courtesy of the Stonewall Jackson House Collection, Stonewall Jackson Foundation, Lexington, Virginia.)

During the dedication ceremony, Stonewall Jackson's granddaughter, Julia Christian Preston, opened the front door of the restored house and museum. Many years earlier, she had attended the dedication of the Stonewall Jackson Statue in the cemetery; see page 99. (Courtesy of the Stonewall Jackson House, Stonewall Jackson Foundation, Lexington, Virginia.)

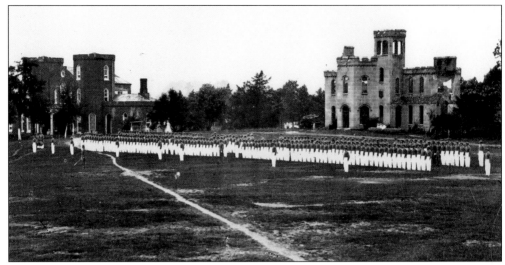

This 1866 photograph shows the damage to Gilham House, next to the superintendent's quarters, resulting from Hunter's raid. During Hunter's stay in Lexington, his troops burned the Virginia Military Institute hospital, the mess hall, the library, and the governor's house. Some of the books the soldiers looted were found along the roads leading out of town. (Courtesy of VMI Archives.)

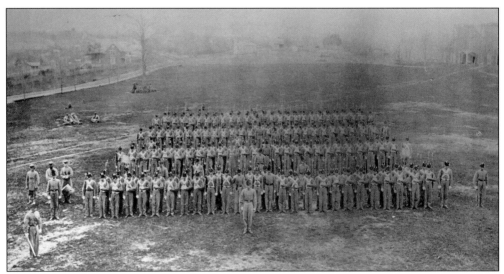

This picture of the Virginia Military Institute class of 1869 is proof that the school survived the Civil War. Directed by the VMI Board of Visitors and Supt. F. H. Smith, Commandant Scott Shipp raised money to make repairs and purchase supplies. (Courtesy of VMI Archives.)

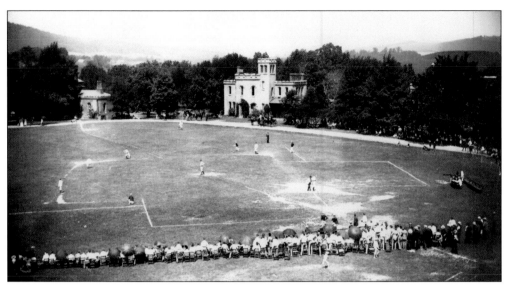

Michael Miley captured this baseball game on the Virginia Military Institute parade ground, as he viewed the game from the barracks looking toward the Gilham House. Many cadets are visible in the foreground, and spectators surround the playing field. (Courtesy of VMI Archives.)

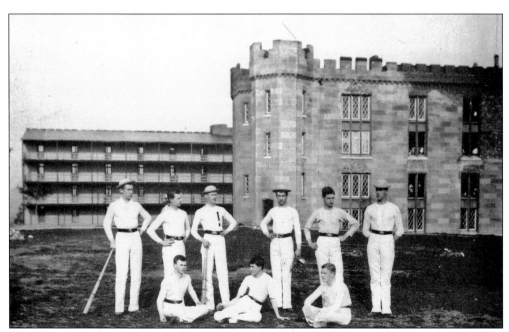

The Virginia Military Institute baseball team for 1884–1885 consisted of, from left to right, (seated) W. L. Hopkins, captain and second base; W. H. Palmer, secretary and treasurer and left field; J. H. Winston, catcher; (standing) R. E. Withers, right field; G. D. Letcher, shortstop; R. L. Wilson, first base; H. Mansfield, third base; V. W. Flowerree, center field; and G. L. Camden, pitcher. (Courtesy of VMI Archives.)

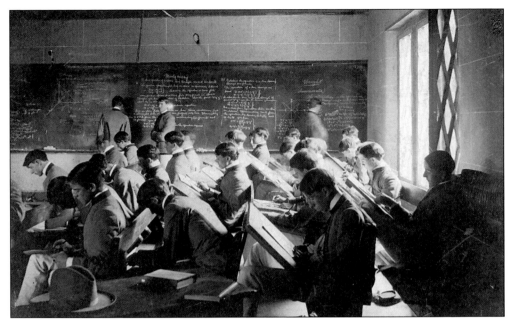

The Virginia Military Institute was modeled on both West Point and L'Ecole Polytechnique in France. All cadets took the same courses, including engineering. Here Prof. Robert A. Marr's engineering class of 1899 has students working at the board under the close supervision of the instructor. Uncomfortable wool uniforms were worn to class. (Courtesy of VMI Archives.)

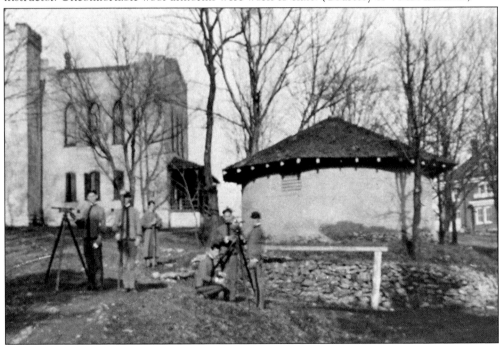

These students using surveying equipment in 1903 are working near the old mess hall at the north end of the Virginia Military Institute. Today you can see the same activity on campus, with cadets using similar, but more modern, equipment, and the necessary calculations are now figured by calculators and computers. (Courtesy of VMI Archives.)

In 1898, the library at the Virginia Military Institute was a pleasant respite from the Spartan life of a cadet. Cadets came to VMI in the fall and stayed there, with almost no time away, until spring. Over the years, more days of furlough have been granted for Thanksgiving, Christmas, and good grades. (Courtesy of VMI Archives.)

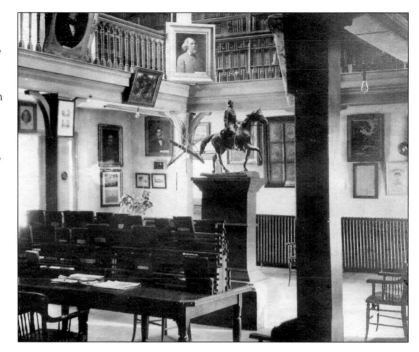

In 1900, a classroom building named for Francis H. Smith was built near the Virginia Military Institute barracks. The three-story building featured a clock tower. In 2008, an addition was constructed to the west side of barracks, and its clock tower is reminiscent of that on the former Smith Hall. To the left is the first Jackson Memorial Hall. (Courtesy of Rockbridge Historical Society Collection; Special Collections, Leyburn Library, Washington and Lee University.)

Virginia Military Institute cook Patrick Payne (around 1890) was among the staff that provided for the needs of the cadets. Hired staff washed and ironed their clothing, cleaned the buildings, and maintained the heating plant in the winter. (Courtesy of VMI Archives.)

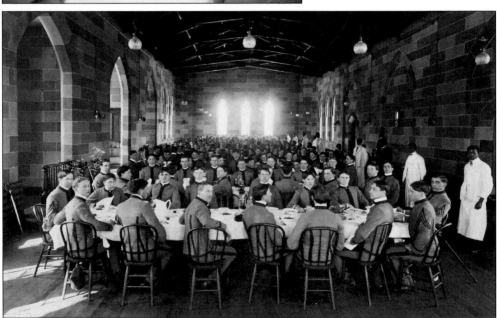

The mess hall is shown here in the early 1900s. Cadet dining style remained the same through the 20th century. They sat at assigned tables, and the food was brought to them in serving bowls, family style. (Courtesy of VMI Archives.)

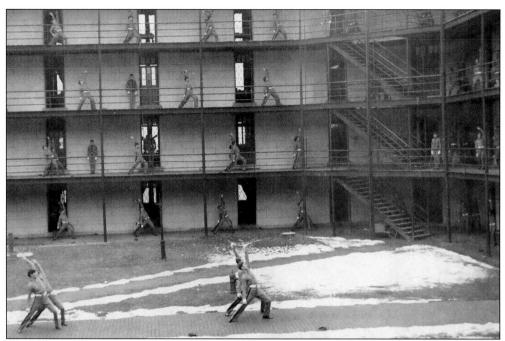

Exercising has always been an integral part of the Virginia Military Institute. This might include long hikes up House Mountain, running for miles in Rockbridge County, working as a group to lift a log, climbing over barriers, and swimming in the Maury River. The workout rooms are popular now, but this photograph shows the cadets being led by the cadre in daily exercises. (Courtesy of VMI Archives.)

A Rat (new cadet) "finns" in the early 1900s. At the command of an upperclassman, a Rat assumed this position as part of the Rat Line training during a cadet's first year, lasting until "breakout" in late winter. Later the act of bracing became part of the tradition of the Virginia Military Institute. It includes standing with hands at the side, head looking forward, chest out, neck tense, back perfectly straight, and chin tucked. (Courtesy of VMI Archives.)

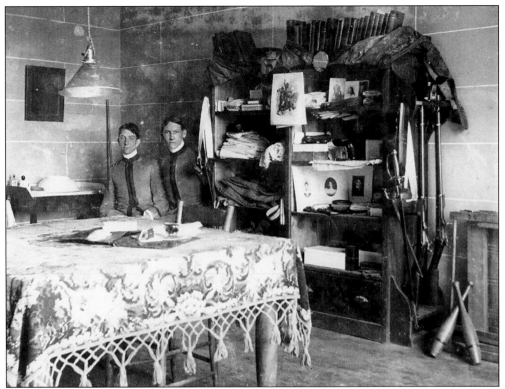

Cadets William P. Upshur and Joseph C. Allen, both VMI class of 1902, take a break from studying in their barracks room. See how this barracks room compares to one in the 1950s (page 116) or a century later (page 119). (Courtesy of VMI Archives.)

This cadet is not happy. The photograph was taken in 1905 but could have been taken any year and it would have looked the same. Whatever the reason, he just does not feel comfortable being where he is. (Courtesy of VMI Archives.)

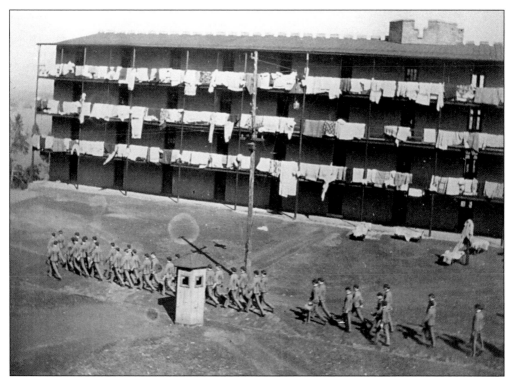

Once a week, the cadet beds "hays" were aired by taking the mattress off of each cot in a barracks room and hanging it outside. At one time, the mattresses were filled with hay, and the name persists. The bed of a cadet is a simple affair: a few slats or springs supported by a wooden frame. The hay was rolled up and placed against the wall during the day to provide more space in the room. This 1904 photograph also shows the sentry box in the courtyard from which orders were relayed to the cadets. (Courtesy of VMI Archives.)

A mundane task is made exciting in this 1910 photograph. The cadet is at the mercy of his roommate, who is giving him a shave, as the chair is precariously close to sliding out from under him. (Courtesy of VMI Archives.)

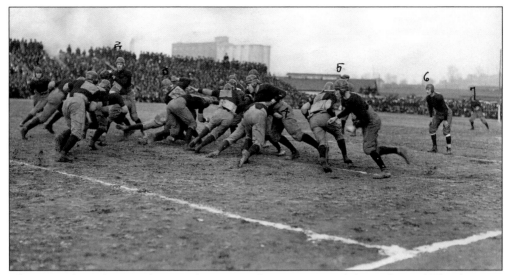

This November 25, 1920, photograph captures the excitement of the traditional Thanksgiving Day football game played between the Virginia Military Institute and the Virginia Polytechnic Institute in Roanoke in bygone days. That year VMI won by scoring 24 points to VPI's 7. The VMI players are 1. Mason; 2. Hunt; 3. Harrison; 4. Summers; 5. Venable; 6. Bunting; and 7. Stuart. The game is no longer played now that VPI has grown to more than 20,000 students while VMI numbers about 1,400 students. (Courtesy of VMI Archives.)

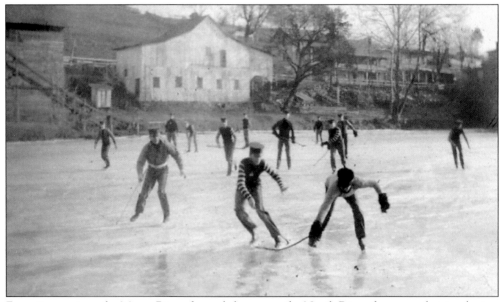

From time to time, the Maury River, formerly known as the North River, freezes so that ice skating is possible. Around 1904, cadets gathered one day for a hockey match in front of Furr's Mill, which was opposite the cliffs behind the barracks. (Courtesy of VMI Archives.)

A visit by lovely young ladies provides a welcome break from the harried routine of cadet life. Perhaps the cadets had read Lord Tennyson in literature class: "In the spring a young man's fancy lightly turns to thoughts of love." (Courtesy of VMI Archives.)

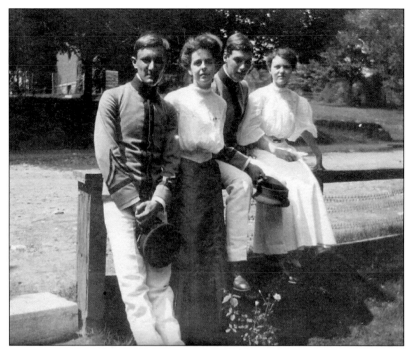

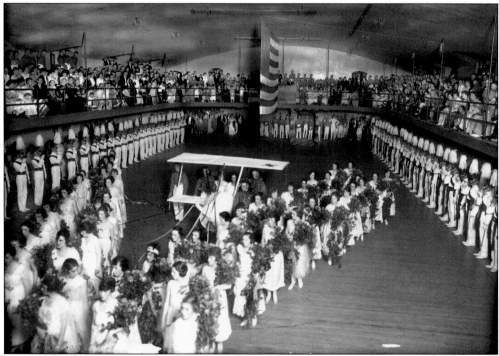

Photographer Michael Miley captured the patriotic pageantry during the Virginia Military Institute's Final Ball in 1918, held on the lower level of Jackson Memorial Hall. The World War I–era crowd in the balcony of the decorated gymnasium, featuring a huge American flag suspended from the ceiling, views a grand entrance of beautiful ladies carrying bouquets of flowers while they form a "V" for victory as their cadet escorts stand at attention. (Courtesy of VMI Archives.)

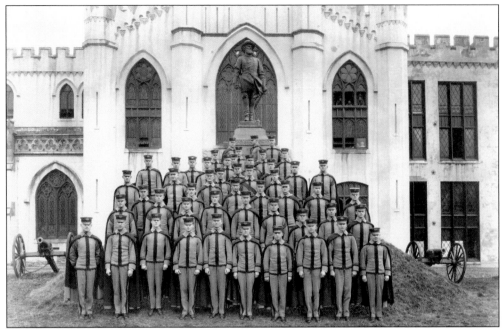

The Virginia Military Institute class of 1916 stands grandly wearing their flowing capes in front of Jackson Arch, as the first Jackson Hall is seen in the background. Today a quotation of Jackson at this main entrance to barracks proclaims, "You may be whatever you resolve to be." (Courtesy of VMI Archives.)

The Virginia Military Institute trumpeter called students to activities and meal formations. Here in 1918, the hired musician stands inside the barracks to call the Corps to breakfast. A hired civilian band marched with the cadets on the parade ground. (Courtesy of VMI Archives.)

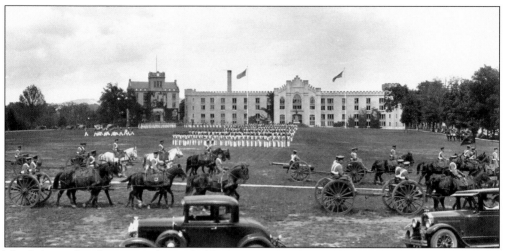

Until the mid-20th century, horses held an important place at the Virginia Military Institute. The stables were located along Main Street, and cadets rode and trained horses at Jordan's Point. Horses were used in formation riding exercises during parades and to pull the artillery, as seen in this 1930s photograph. (Courtesy of VMI Archives.)

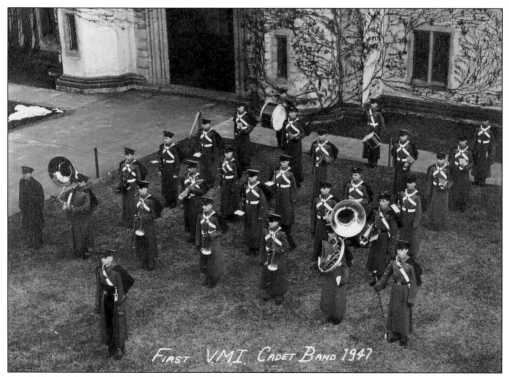

In 1947, the first cadet band was formed. The Virginia Military Institute band has grown in size and currently includes a Scottish bagpipe unit. The band plays for Friday parade reviews, which are open to the public. They appear in many parades off campus, such as those for Virginia governors and the Rose Bowl Parade. In the president's inaugural parade, they appear with the entire Corps of Cadets. (Courtesy of VMI Archives.)

Cadets stand at Washington Arch with William J. Hubard's bronze cast of Jean Antoine Houdon's original marble statue of George Washington, located in the state capitol at Richmond. Installed at VMI in 1856, Union troops during Hunter's raid seized the statue and took it to Wheeling, West Virginia. It was returned to the Institute in 1866 and stands at Washington Arch, facing toward the barracks. (Courtesy of VMI Archives.)

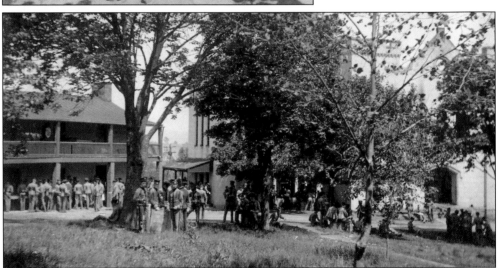

The mess hall burned in 1905. In this photograph, cadets are eating outside on the lawn in front of the mess hall. It represents a trait of VMI graduates; they solve problems in an efficient and effective manner. The building on the left is the old VMI hospital; built in 1848, it still stands at the same location. (Courtesy of VMI Archives.)

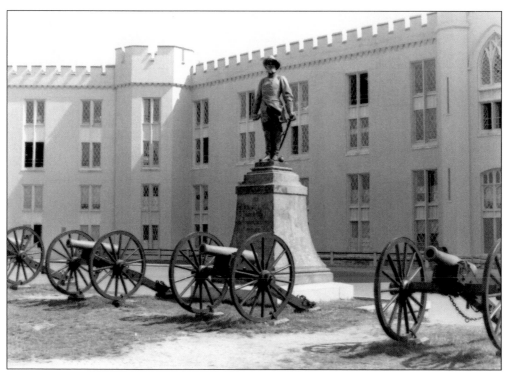

The four cannon—known to cadets as Matthew, Mark, Luke, and John—that flank Moses Ezekiel's statue of Stonewall Jackson were used by Professor Jackson (1851–1861) during cadet artillery training. The guns later acquired their names because they were said to speak the Confederate gospel in a powerful language. Ezekiel's statue portrays Stonewall Jackson on the battlefield, his coat blowing open. On the base of the statue are engraved the words of Jackson a short time before his wounding at Chancellorsville: "The Institute will be heard from today!" (Courtesy of George C. Marshall Library.)

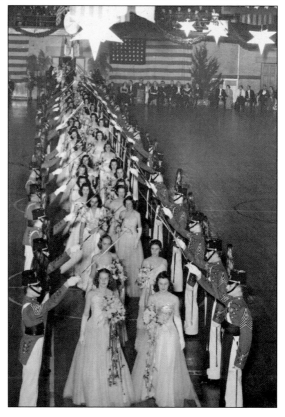

In 1939, the Virginia Military Institute held a Centennial Ball. Imagine the changes that the institute had gone through in those 100 years. The ball featured an introductory march followed by an evening of dancing. As with all VMI dances, the chaperones were drawn from the faculty and staff. (Courtesy of VMI Archives.)

These 1958 students of Prof. Lee Nichols are doing what was called daily recitation. This was a written quiz or work at the blackboard. It is a method that requires a student to keep up with the subject matter in each class. (Courtesy of VMI Archives.)

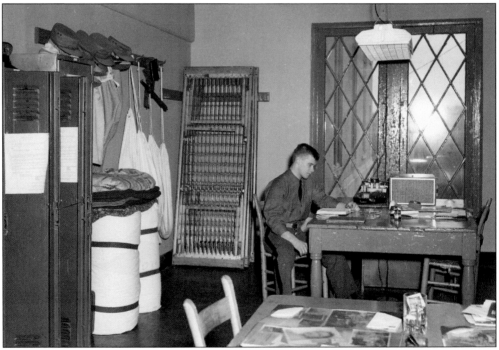

Compare this 1958 scene to the 1902 photograph of a typical cadet room. The room is about the same size, the hays are rolled, and the hay racks (bed frames) lean against the wall. (Courtesy of VMI Archives.)

Graduation is a special event at the Virginia Military Institute. The cadets may choose to take a commission in the military if it is offered, continue with their education, or take a job in the private sector. This 1960s scene shows the barracks courtyard celebration following graduation—one of the few times that family and friends are allowed inside the barracks area. (Courtesy of Andre Studio.)

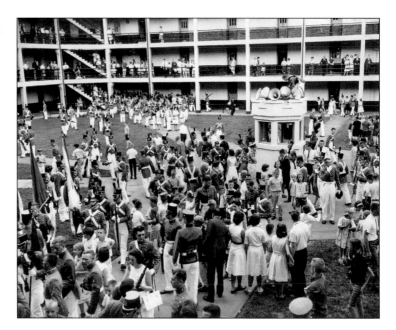

The Virginia Military Institute was one of the first colleges in the United States to adopt the class ring tradition. The oldest ring in the collection on display at the VMI Museum dates from 1848. Each year, a committee of the third-class cadets (sophomores) designs the class ring. The cadets receive their rings at a ceremony held during their second-class (junior) year. Wearing the ring is deemed one of the greatest rewards of the VMI experience. In later years, alumni often recognize each other by these rings. (Courtesy of the VMI Museum.)

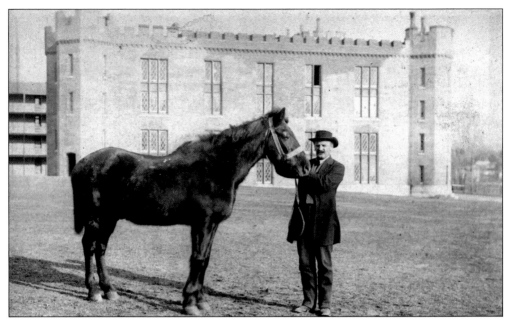

Stonewall Jackson's horse, Little Sorrel, was photographed around 1880 by Michael Miley in front of the VMI barracks. When the horse died in 1886, he was at the Old Soldier's Home in Richmond, Virginia. His hide was mounted by Smithsonian Institution taxidermist Fredrick Webster. (Courtesy of the VMI Museum.)

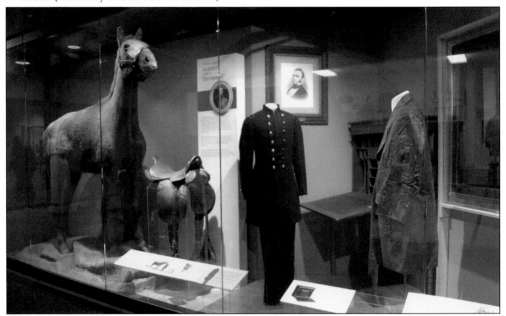

One exhibit in the VMI Museum displays several items that belonged to Gen. Thomas J. Jackson. From left to right are his horse Little Sorrel, a saddle given to Jackson by British admirers, and a blue uniform coat he wore in the VMI classroom. He was wearing the coat at the Battle of Manassas when he received his nickname "Stonewall." The desk Jackson used at VMI and during the war is displayed, as well as the raincoat he was wearing when mortally wounded. (Courtesy of the VMI Museum.)

The entire Virginia Military Institute Cadet Corps, numbering about 1,400 men and women, lives in the barracks. The oldest part of the building dates from 1850. Many additions and modifications have resulted in the current barracks, including the newest addition opened in 2009. Each room houses from three to five cadets. (Courtesy of the VMI Museum.)

Established in 1856, the VMI Museum is the oldest museum in the Commonwealth of Virginia. This is a 1935 photograph of the museum. It now houses over 12,000 artifacts relating to VMI history and is accredited by the American Association of Museums. (Courtesy of the VMI Museum.)

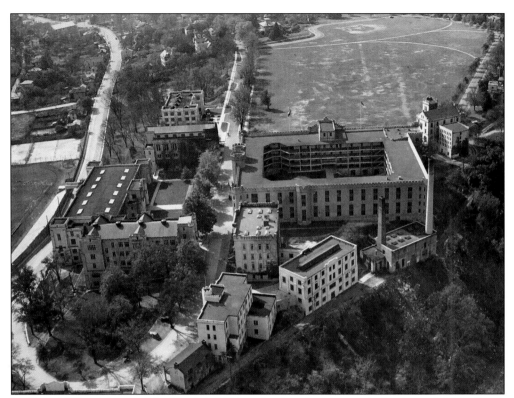

In this *c.* 1935 aerial view of the Virginia Military Institute looking south, Lexington's Main Street (Route 11) is on the left. At the turnoff near the back of Cocke Hall, the road curves up the hill past the mess hall and old hospital, continuing to the barracks and parade ground. (Courtesy of Rockbridge Historical Society Collection; Special Collections, Leyburn Library, Washington and Lee University.)

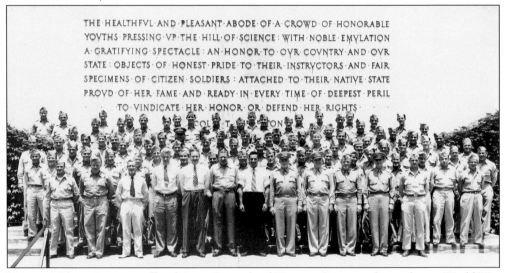

Virginia Military Institute offered Army Specialized Training Program classes during World War II. Among the many students in the ASTP was Melvin Kaminsky (comedian Mel Brooks), who attended VMI during May to July 1944. (Courtesy of VMI Archives.)

First Classman George C. Marshall poses wearing his furlough coat. In January 1901, VMI superintendent Scott Shipp said of Marshall, "He is of fine physique and soldierlike appearance; a young man of marked character and ability, with natural powers of command and control." (Courtesy of George C. Marshall Library.)

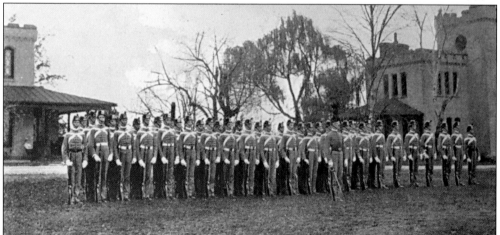

Company A of the Virginia Military Institute Corps of Cadets drills on the parade ground during the 1900–1901 session. Cadet 1st Capt. George C. Marshall, commanding, stands with his company at attention. Marshall later recalled, "The first thing was I tried very hard. I was exact in all my military duties and I was gradually developing in authority." (Courtesy of George C. Marshall Library.)

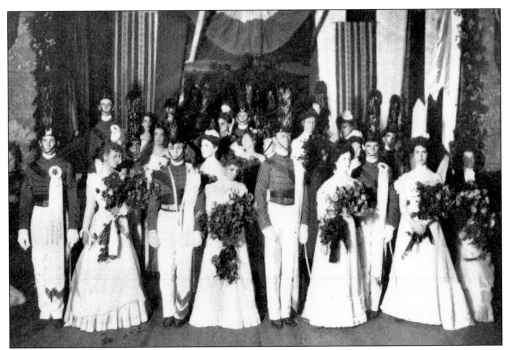

Cadet George C. Marshall (first row center; third cadet from the left) participates in the Virginia Military Institute's Final Ball on July 4, 1900. (Courtesy of George C. Marshall Library.)

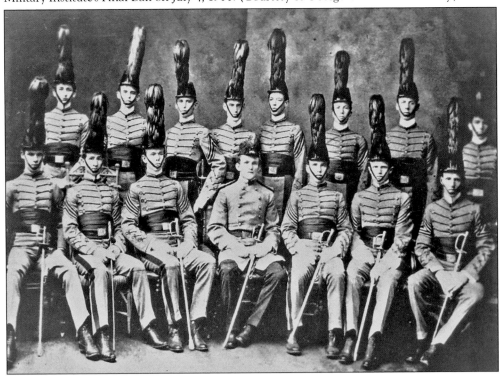

George C. Marshall (third from the left in the first row) poses with the VMI cadet staff attired with dress shakos in 1901. (Courtesy of George C. Marshall Library.)

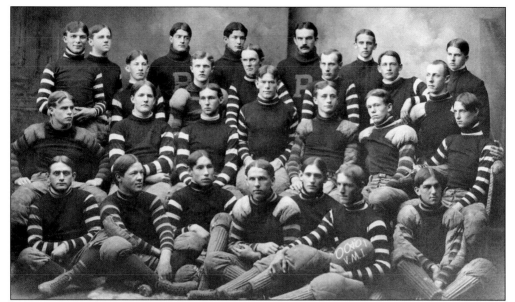

The Virginia Military Institute's football team is photographed in 1900. Cadet George C. Marshall (second row, second from right) played left tackle on the team. Marshall wrote in 1928, "My idea of a cadet on the field is one of quick action, speed, and a relentless fighting determination to stop the other fellow or to go forward." (Courtesy of George C. Marshall Library.)

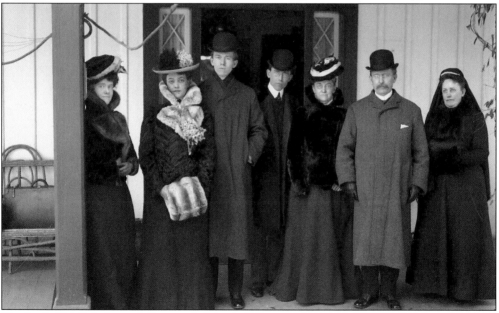

Elizabeth "Lily" Coles and George C. Marshall Jr. were married on February 11, 1902, at the bride's home (Pendleton-Coles House located near the VMI Limit Gates) on Letcher Avenue in Lexington. "She was the finest amateur pianist I ever heard," Marshall recalled of Lily. "I heard her playing and that brought about my meeting with her." The Marshall-Coles wedding party poses on the front porch. From left to right are Marie (George's sister), the bride and groom, Stuart (George's brother), Mr. and Mrs. George C. Marshall Sr., and Mrs. Walter Coles. (Courtesy of George C. Marshall Library.)

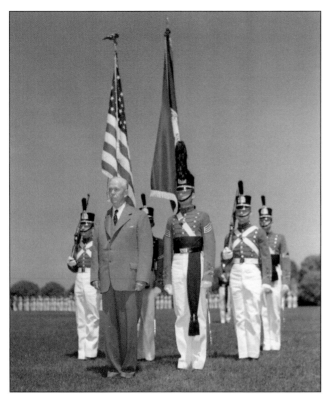

During his 50th class reunion, Secretary of Defense George C. Marshall was honored at a regimental review of the Virginia Military Institute Corps of Cadets during the dedication of Marshall Arch entrance to barracks on May 15, 1951. Two years later, the George C. Marshall Foundation was established to promote the legacy of Marshall by constructing a library to preserve his memorabilia and letters for researchers. (Courtesy of George C. Marshall Library.)

Gen. George C. Marshall talks with First Classmen Victor Parks III and Paul Scott Williams Jr. beneath Marshall Arch at VMI on May 15, 1951, during dedication ceremonies naming this entranceway into barracks. A plaque there quotes Pres. Dwight D. Eisenhower saying of Marshall, "He is a patriot, a distinguished soldier, and the most selfless public servant I have ever met." (Courtesy of George C. Marshall Library.)

Pres. Lyndon B. Johnson and Gen. Omar N. Bradley lead the procession of dignitaries during the dedication ceremony of the George C. Marshall Research Library in Lexington on May 23, 1964. "Succeeding generations must not be allowed to forget his achievements and his example," wrote British prime minister Winston S. Churchill. (Courtesy of George C. Marshall Library.)

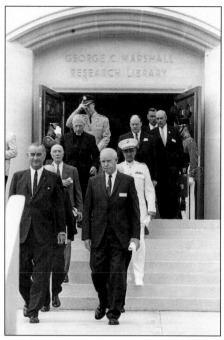

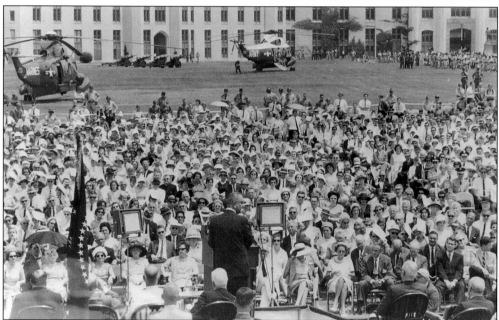

President Johnson speaks during the dedication ceremony for the Marshall Library on May 23, 1964. "Today we work to carry on the vision of the Marshall Plan," stated Johnson, "to strengthen the ability of every European people to select and shape its own society, to bring every European nation closer to its neighbors in the relationships of peace." George Marshall "was among the noblest Americans of them all," he concluded. "Not only a soldier, not only a great statesman, he was first and foremost a great man." The crowd may not have remembered what the president said, but they did remember the tremendously hot day, as witnessed by umbrellas and makeshift paper hats used to shield the sun. (Courtesy of George C. Marshall Library.)

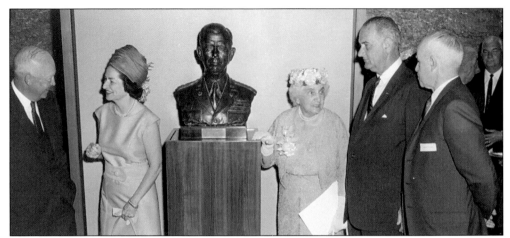

Former president Dwight Eisenhower talks with Lady Bird Johnson as Marshall's widow, Katherine Marshall, talks with President Johnson and Gen. Omar Bradley in the lobby of the newly dedicated Marshall Library. The library and museum house George C. Marshall's papers and document his half century of public service. He served as U.S. Army chief of staff (1939–1945), special ambassador to China (1945–1946), Secretary of State (1947–1949), president of the American Red Cross (1949–1950), and Secretary of Defense (1950–1951). (Courtesy of George C. Marshall Library.)

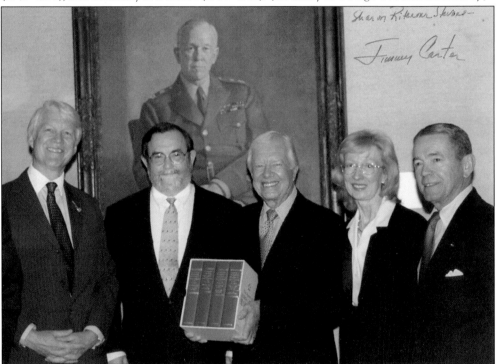

The editors of *The Papers of George Catlett Marshall* (Johns Hopkins University Press) presented former president Jimmy Carter with the first four volumes of the documentary edition during his March 29, 2001, visit to the George C. Marshall Museum. Pictured from left to right are Albert J. Beveridge III, Marshall Foundation president; Larry I. Bland, editor, *Marshall Papers*; President Carter; Sharon Ritenour Stevens, associate editor, *Marshall Papers*; and Gen. John W. Knapp, foundation trustee and mayor of Lexington. (Courtesy of George C. Marshall Library.)

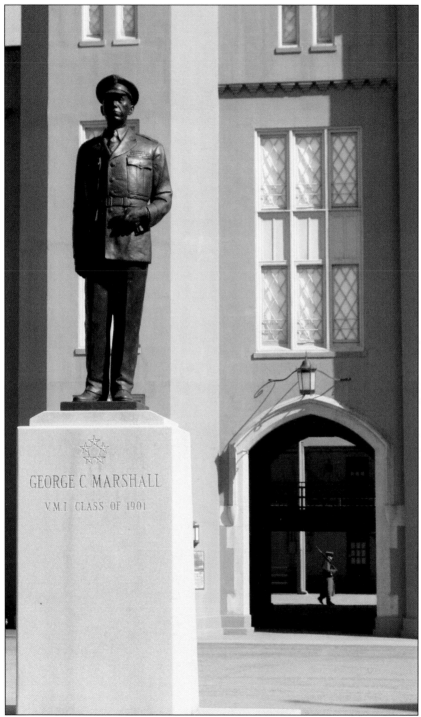

Alumni of Virginia Military Institute paid special tribute to General Marshall by erecting this statue by sculptor Augusto Bozzano in front of Marshall Arch in November 1978. Soldier-statesman George C. Marshall's accomplishments reached worldwide, and so do his tributes; in December 1953, he received the Nobel Peace Prize in Oslo. (Courtesy of VMI Alumni Association/Kathryn Wise.)

Discover Thousands of Local History Books
Featuring Millions of Vintage Images

Arcadia Publishing, the leading local history publisher in the United States, is committed to making history accessible and meaningful through publishing books that celebrate and preserve the heritage of America's people and places.

Find more books like this at
www.arcadiapublishing.com

Search for your hometown history, your old stomping grounds, and even your favorite sports team.

Consistent with our mission to preserve history on a local level, this book was printed in South Carolina on American-made paper and manufactured entirely in the United States. Products carrying the accredited Forest Stewardship Council (FSC) label are printed on 100 percent FSC-certified paper.

MADE IN THE USA